IMAGES
of America

CORNING

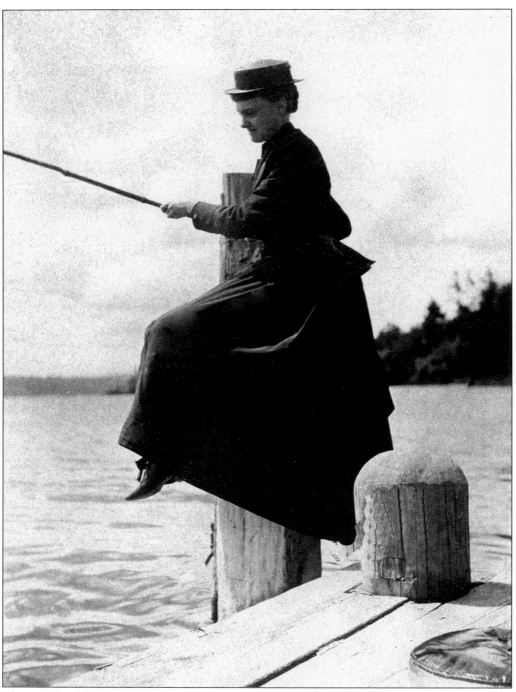

The wealth of the Drake family, of Corning and Keuka Lake, relieved them of domestic chores and allowed time to pursue sports, the arts, and travel. They lived life to its fullest.

IMAGES of America

CORNING

Charles R. Mitchell and Kirk W. House

ARCADIA

First printed in 2003.

Published by Arcadia Publishing,
an imprint of Tempus Publishing Inc.
2A Cumberland Street
Charleston, SC 29401

Printed in Great Britain.

Library of Congress Catalog Card Number: 2003107794

For all general information, contact Arcadia Publishing:
Telephone 843-853-2070
Fax 843-853-0044
E-mail sales@arcadiapublishing.com

For customer service and orders:
Toll-free 1-888-313-2665

Visit us on the Internet at www.arcadiapublishing.com.

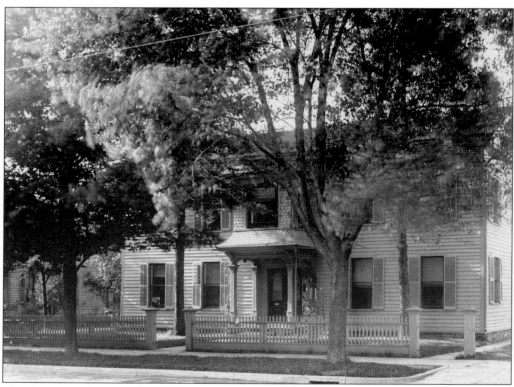

The Benjamin Patterson Inn, seen here in a late-19th-century photograph, is now the home of the Corning-Painted Post Historical Society.

CONTENTS

ACKNOWLEDGMENTS

All photographs appear with the kind permission of the Corning-Painted Post Historical Society. When you visit Corning, stop at the historical society's Benjamin Patterson Inn, an 18th-century hostelry acquired and lovingly restored after the great flood of 1972. The related Painted Post-Erwin Museum at the Depot operates nearby in a former Delaware, Lackawanna and Western station.

Nearly all the photographs in chapters 1 and 4 are drawn from the Drake collection, and nearly all were created by Isabel Walker Drake. The formal photographs from Ogontz were probably produced by the school. We have used a topical approach rather than a chronological one.

We extend our thanks to Carrie Fellows, curator of the Corning-Painted Post Historical Society, who helped us dig into all of this marvelous material; Melissa Mitchell for her technical assistance; Roger Grigsby, director of the Corning-Painted Post Historical Society; Mary Ann Sprague, who did much to preserve this history and keep its memory alive; and Nancy Dorwart, who first brought the Drake collection to our attention, telling us that the collection would excite us *and* that something had to be done with it. She was right on both counts.

INTRODUCTION

"THEY HAD FUN"

Corning, New York, for all that it is headquarters to a Fortune 500 corporation, is still a small town. It was even smaller as the 19th century turned to the 20th. Smoke belched from the tall stacks of the glassworks on the Southside, mingling with smoke from the brick works on the Northside.

Business was booming in Corning, as it was in most of America. With an expanding frontier, a rebuilding former Confederacy, new imperial possessions, and explosive technological innovations, fortunes arose (and sometimes collapsed) overnight. In Corning's next-door town of Elmira, Mark Twain scratched out his wry observations and perfectly labeled his era the Gilded Age.

Margaret Higgins, sixth of 13 children, struggled through the life of the industrial poor in Corning. She later married Charles Sanger and, in 1914, began a crusade for birth control. Tom Watson studied in a one-room school (still standing at Watson Homestead in nearby Coopers Plains) and made such a nuisance of himself at the local hardware store that his boss sent him out on the road. Watson eventually became president of International Business Machines (IBM) in Rochester. In the 1940s, with no scientific or technical training, he discontinued all existing lines and bet his entire company on building the first IBM computer.

In 1880, a team of Corning glassworkers, consulting with a technician from Thomas Edison's lab, created the very first bulb for electric light. In several summers c. 1902, bike mechanic Glenn Curtiss (from nearby Hammondsport) operated a seasonal shop in Corning. Curtiss quickly gave it up, however. He was consumed first by making motorcycles and then by building the biggest airplane business in America.

During the 1880s, James Drake inherited his father's substantial interest in Corning's First National Bank. He also became involved with his father-in-law's Corning Building Company. Other ventures followed, and James Drake provided his family with a lifestyle fully in keeping with that extravagant age in which income tax was only a distant dream.

Isabel Walker Drake immortalized her family's bright and loving life with George Eastman's new Kodaks, including a marvelous panoramic camera. Although Eastman made millions by creating roll film that you could send to Rochester for processing, Isabel Drake was a purist. Her bathtub was frequently filled with developing fluids while towel racks were festooned with drying prints and negatives.

The Corning-Painted Post Historical Society holds five large boxes of Drake family scrapbooks at its Benjamin Patterson Inn museum. Besides being a loving mother, Isabel Drake was a first-rate photographer. Her work is a stunning visualization of the Gilded Age at its very best. It is also a marvelous record of Corning, Keuka Lake, and nearby communities (not to mention a record of the Drakes' far-flung travels).

Isabel and James Drake had three daughters—Margaret (Madge), Martha, and Dorothy (Dort)—all of whom bustle through these scrapbooks while enthusiastically sampling life. The

restrictions of Victorian womanhood were not for the Drake girls—not when they could swim, bike, snowshoe, dive, or even box. Also springing from the photographs are cousins Sid and Glen Cole, who matched the girls in enthusiasm. The boys spent much of their summers under canvas on the shores of Keuka Lake, apparently disdaining the huge "cottages" of Drake's Point.

The good times could not last, of course. Even before income tax was established, overspending, bad management, and hard times conspired to end the Drakes' long idyll. Madge became a secretary at Corning Glass Works. Dort gave cello lessons. Sid was killed in action with the American Expeditionary Forces in World War I.

After the girls died, their mother's scrapbooks were sold for a song. However, an enlightened buyer recognized their significance, arranged for samples to be published in *American Heritage,* and returned the books to the people of Corning, as represented by their historical society. In the words of society member Mary Anne Sprague, who knew some of the family in their old age, "They had fun. And they were fun." They still are.

One
At Home

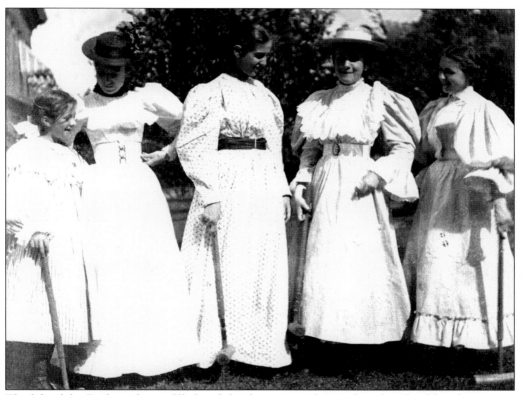

The life of the Drake girls was filled with bright summer dresses, broad smiles, blue skies, green lawns, and croquet. However, if the girls were lavished with indulgence, they used their opportunities for self-development, mastering challenges educational, artistic, and athletic. We could envy their material comforts, but we could even more deeply envy the love that was manifest throughout their family life.

A few blocks away, Margaret Sanger helped her mother with the backbreaking work of industrial poverty. In times to come, through no fault of their own, the Drake girls' fortunes would fall. Sanger's fortune, through determination and hard work, would rise.

The experiences of both families (and of millions more like them) laid the foundation of new opportunities for women in the 20th and 21st centuries. As the 19th century closed, however, with hard times far beyond the horizon, the Drake home was a magical place. Isabel Drake's camera is our magic mirror on their world.

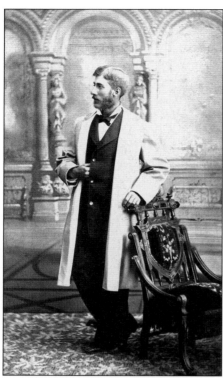

James Drake looks every inch the prominent businessman and paterfamilias that he was.

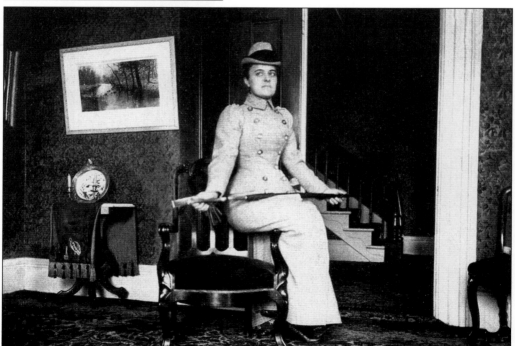

Isabel Drake, although still very formal, presented herself as a bit more "with it." As befits someone of her social group, she appears fashionably dressed in all her photographs.

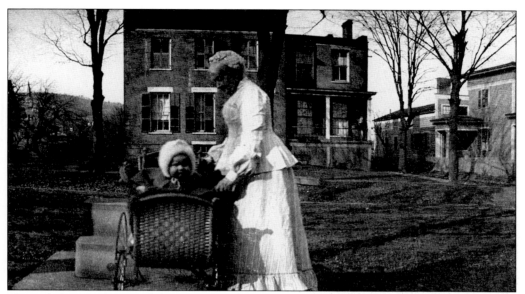

The girls frequently visited their grandmother Maria Walker, who lived in Corning part of the year. The house in the background, across Walnut Street, is now Beilby Funeral Home.

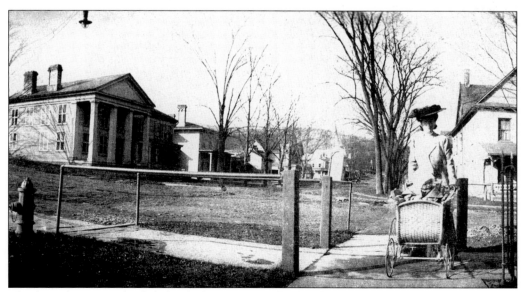

The large house to the left (with four square pillars) still stands on the corner of First and Walnut Streets. The house on the opposite corner is now the office of Dr. James Felli.

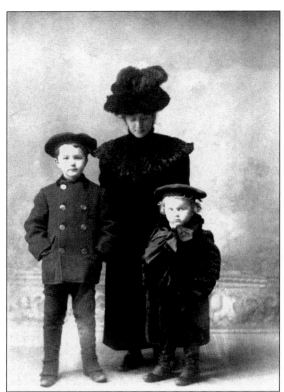

Martha Drake seems to be conscientiously shepherding her young cousins for this formal portrait. Sid and Glen Cole are taking it in stride.

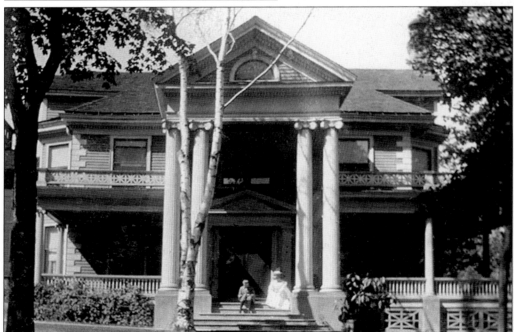

The Cole house (later Van Campen's) bespoke success. This palatial home, still looking very much like this today, stands on Cedar Street between Fourth and Fifth Streets.

Cousin Glen Cole's ceramic pig shows up in numerous photographs, as does that elaborate vase.

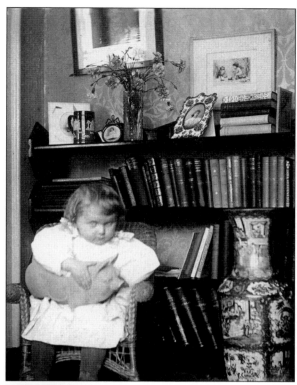

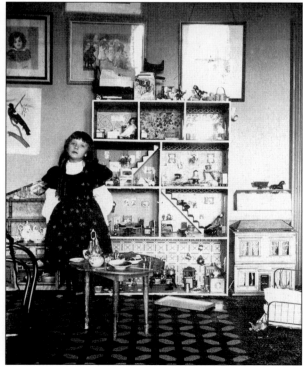

This doll house is surely big enough to satisfy even three little girls. The one on the right would have thrilled most girls at that time. The Drake girls also had a walk-in playhouse in their backyard.

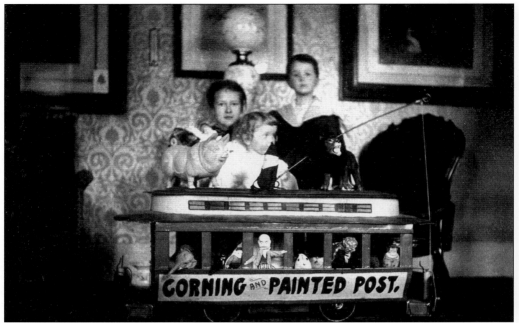

One Christmas morning unveiled this large model of the local street railway. The real trolley can be seen on page 76.

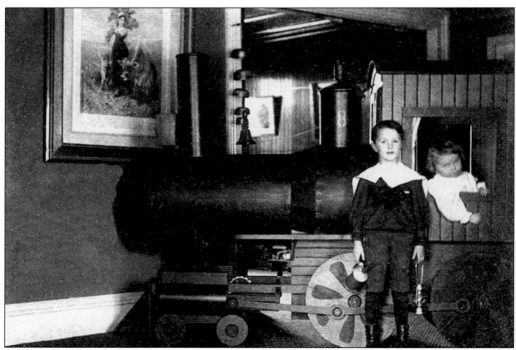

Workers at the Corning Building Company created this "wonderful locomotive" for Glen, Sid, and Dorothy at Christmas in 1897. Note that Sid carries a lantern and oil can. All that is lacking is the engineer's cap.

"Minnie" had primary care of the Drake girls. This photograph was taken in front of the Drake house at the corner of First and Cedar Streets. The Methodist church is across the corner.

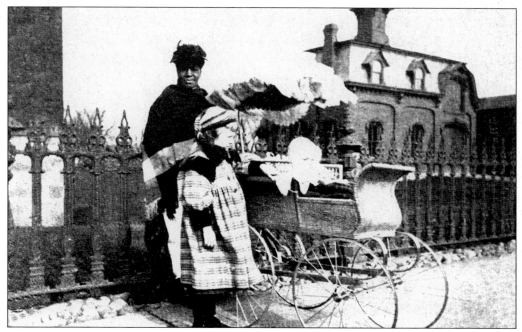

Sometimes, Mrs. Green took the Drake girls in hand. She and her husband, Ed Green, were longtime employees of the Drakes.

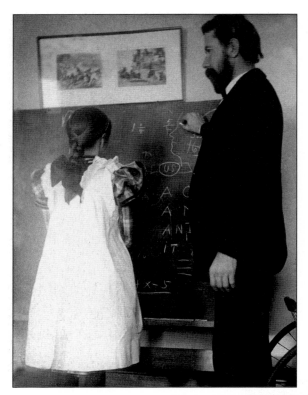

The Drake girls were educated at home, under the tutelage of Prof. John C. Bostlemann, known to the girls as "Mr. B." The professor operated the Corning Conservatory of Music, making him an ideal tutor.

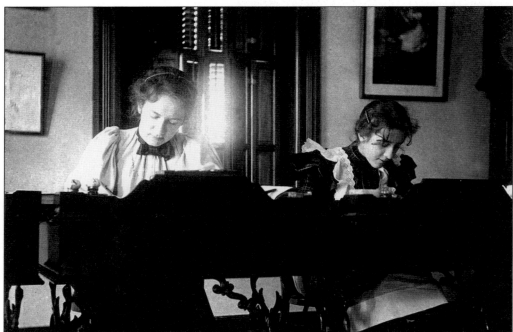

Madge and Martha Drake's attire demonstrates that work in the schoolroom was taken seriously. Note that each has her own desk.

Martha Drake learned to play the family pipe organ. This organ is now used at the Presbyterian church in Pulteney.

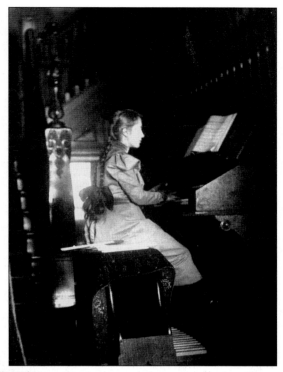

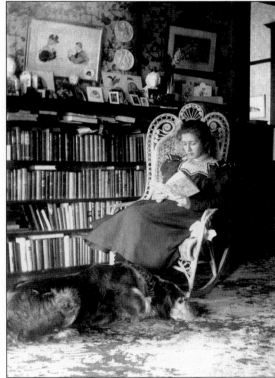

Martha was once described as being "happiest among her books." The Drake home had many books, which can be seen in most of the interior images. The old family dog, Bailey, appears comfortable at Martha's feet.

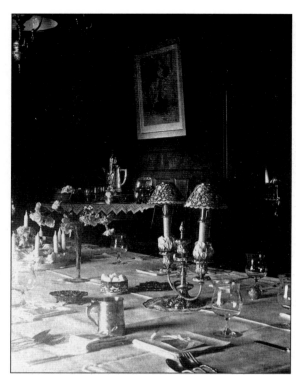

The dining room table is very elegantly set for a special occasion or a Sunday dinner.

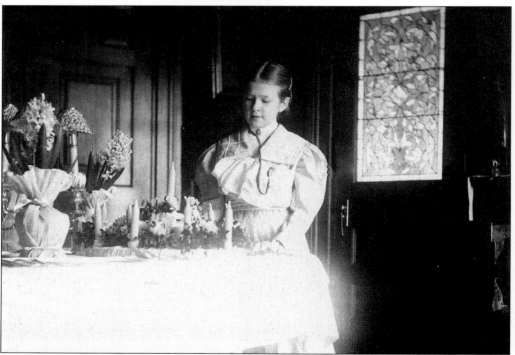

Dort's eighth birthday occasioned a lavish celebration. Notice the stained-glass window in the door behind her. Is it a Tiffany?

18

The musical family's new phonograph was undoubtedly a big hit, although Dort looks unusually stiff for one of Isabel Drake's photographs. The "records" were wax cylinders, all of which were eventually destroyed by the needles gouging along the interior grooves.

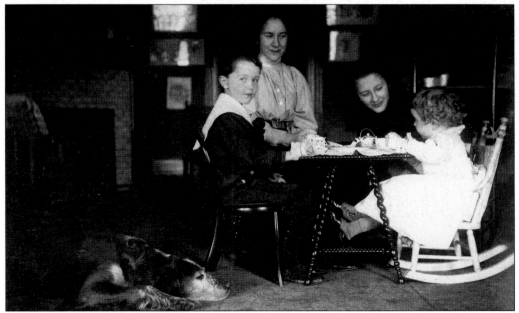

Madge and Martha Drake are obviously enjoying having a tea party for cousins Sid and Glen Cole, but Old Bailey takes it all in stride. Presumably one of the hired help fastened up little Glen's puttees every morning.

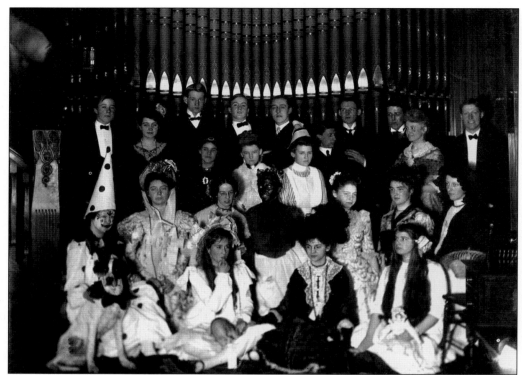

Theatrical and musical extravaganzas were regular aspects of life with the Drakes. Behind the ensemble is the family's home pipe organ, made by Beeman of Binghamton.

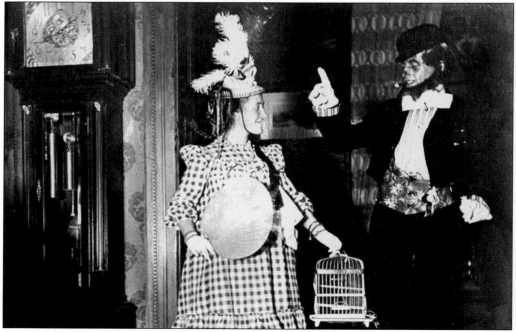

Apparently, this particular production was a farce.

Other evenings were far more formal. This affair occupied the entire third floor of the Drakes' Second Street home, with a platform for the orchestra. Martha and Madge Drake, Jessie Hayt, and Julia Olivia Langdon were guest violinists. Mr. Beeman of Binghamton gave an organ recital. Mr. Morse of Penn Yan was the guest flautist. Julia Olivia Langdon was a relative by marriage of Mark Twain.

Musicale at the residence of

Mr. James A. Drake,

by the

✦ Alliance ✦ Orchestra ✦

assisted by Miss Langdon, of Elmira, Miss Hayt and the Misses Drake.

Thursday evening, January 7, 1897.

✦ Program. ✦

I.—Two Step—The Band's ComingSchild
II.—Waltz—Daughter of LoveBennett
III.—Surprise SymphonyHaydn
IV.—War March of the PriestsMendelssohn
V.—Ouverture — StradellaFlotow
VI.—Selection—FaustGounod
VII.—Two Step—Master MinerZeller

DOERSH. THE PRINTER.

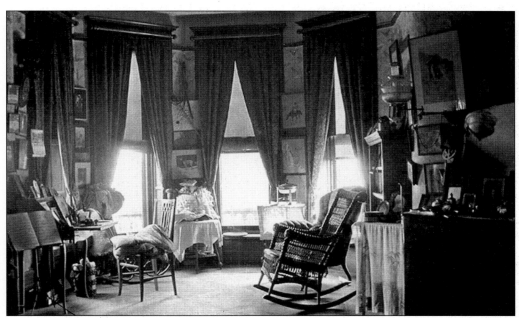

Musical paraphernalia was only to be expected in the Drake home. Unlike the Victorian-era fashion of dark, stuffy rooms, this one is bright and airy.

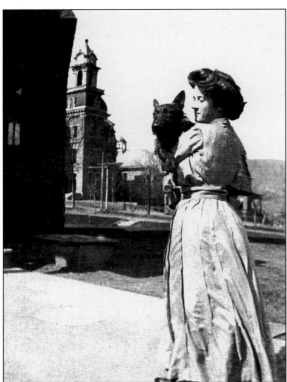

Scotties were a favorite breed. In this view, Martha is holding Thistle. The old Corning Free Academy, a public school, is seen in the background.

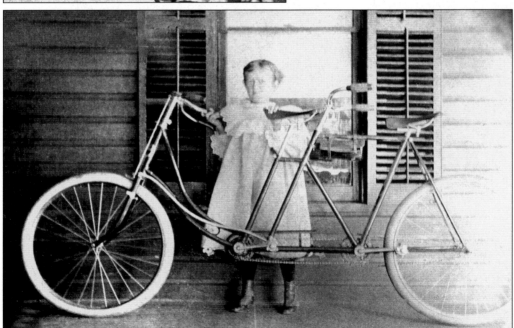

Life outside the home was also exciting and busy. It is no surprise that the energetic Drakes caught the 1890s cycling craze. This bicycle built for two was for the parents, not for the daughter posing here.

Larger versions of this tricycle gave safety bikes a run for their money on American streets. The pedals were pumped in an up-and-down motion rather than a circular one, making them harder to operate.

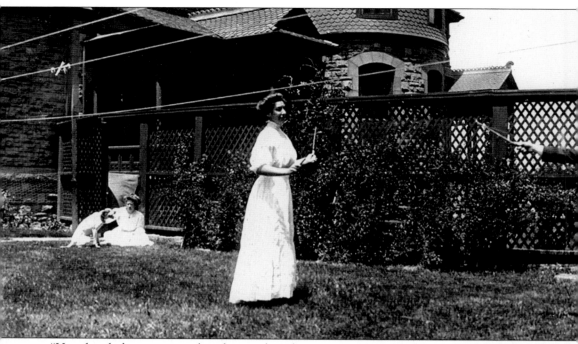

"Heard melodies are sweet, but those unheard are sweeter." Out by the clothesline is a fine spot

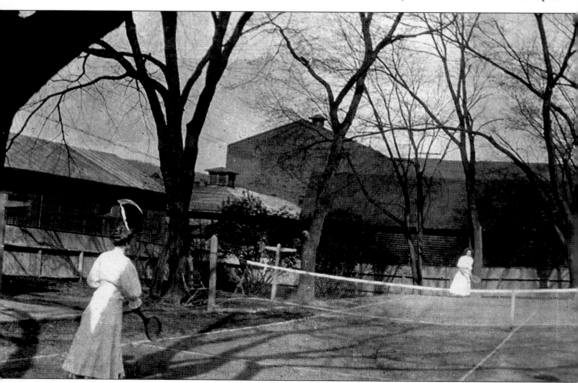

Even tennis (at the Palmyra farm of the girls' grandfather) is predictably played in necktie and long

to practice orchestra conducting.

dresses. This panoramic image was taken by Isabel Drake with her new No. 4 Kodak Panoram.

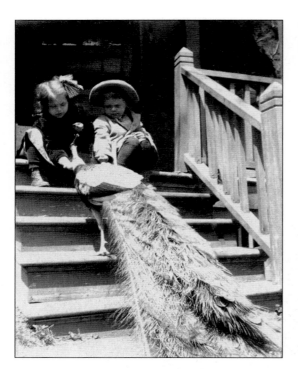

The children seem unsure about this peacock at their grandfather's farm.

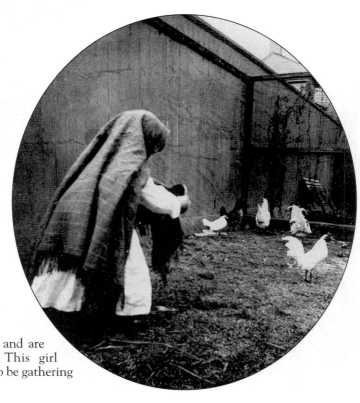

Chickens may be more fun and are certainly more practical. This girl appears to be a little young to be gathering the eggs.

Getting all dressed up (perhaps for Easter) was apparently not much of a thrill. The glassworks chimneys are in the far background. The Baptist church is on the right.

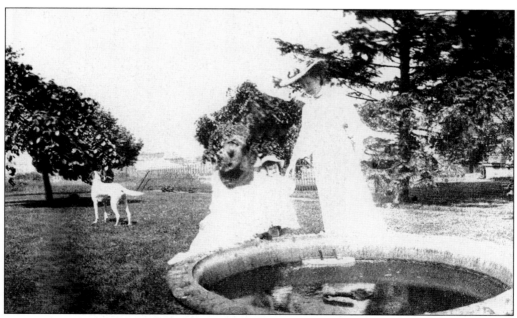

Dort and Madge Drake are using the front-yard pool for naval maneuvers. The Hawkes house (which still stands) is in the right background.

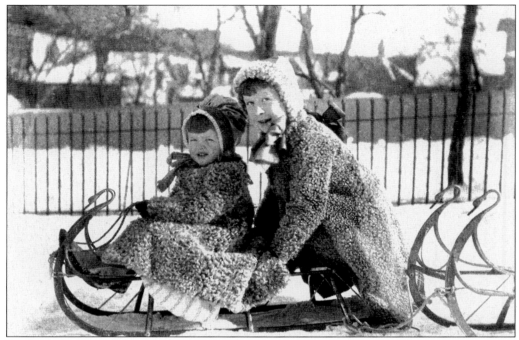

In wintertime little girls could take to sleds. Corning's Southside provided numerous hills for sled riding.

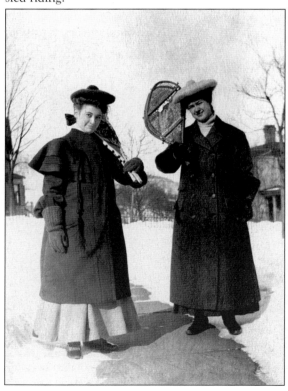

As big girls, the Drake daughters could tramp through the neighborhood in snowshoes. Those same hills may not have been as welcome.

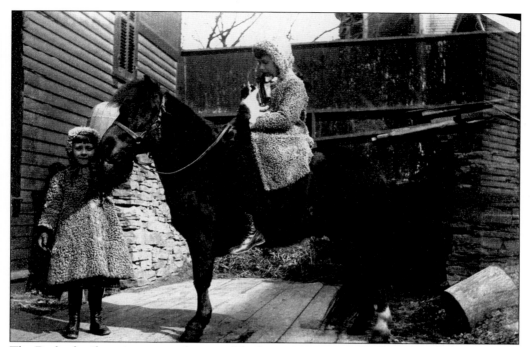

The Drake family was young as the age of the horse was waning. Well-to-do girls (and kittens) rode from an early age.

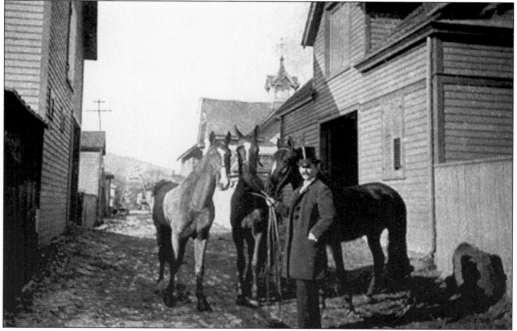

A prominent household required a substantial stable. The Drake stable was on an alley between Second and Third Streets. Many of Corning's Southside blocks are bisected by alleys.

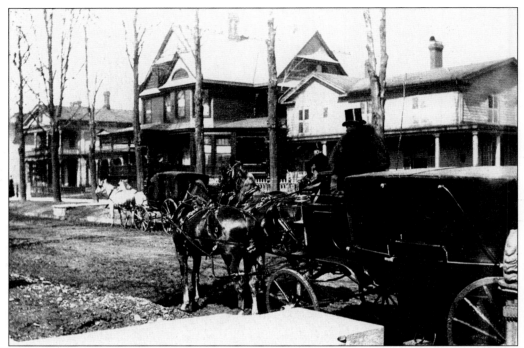

Horse-drawn conveyances (for business, style, and pleasure) varied as widely as do motor vehicles today. This may be the occasion of cousin Martha Hoyt's wedding to T.P. Fiske of New York City and Westbrook, Connecticut.

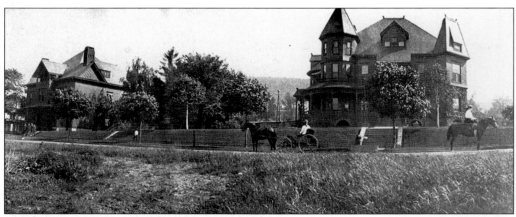

Dort is driving (or standing) while Martha is riding (or sitting) in front of the Drake house. The Hawkes house is to the left. Several presidents ordered T.G. Hawkes cut glass for the White House. The Drake site is now a fenced-in lot behind Corning Free Academy, but the carriage block at the foot of the stairs is at the Benjamin Patterson Inn.

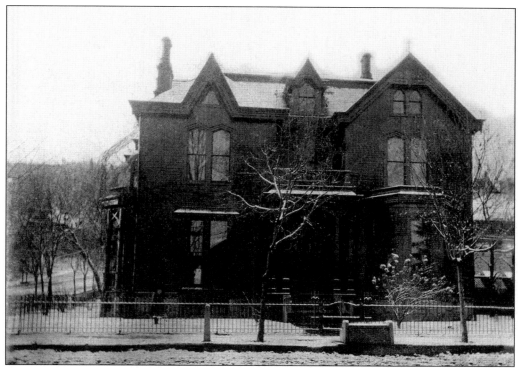

The big brick house on the hill was a step up from the family's "starter" at First and Cedar Streets. Today, the door on the Cedar Street side bears a plaque reading, "Drake House."

Laureta, the parrot, was another in the young family's menagerie. In warm weather, the bird could go outside for some air.

Victorian decorators abhorred empty space. It is unusual that the wallpaper itself is not elaborately patterned. The children were lucky to have someone put their toys away, or did they have to do that chore themselves?

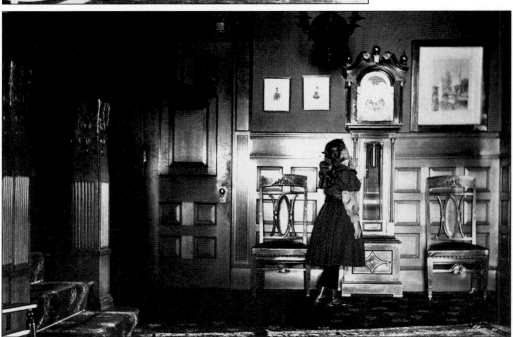

The decor in this room is remarkably restrained, setting off the elegant woodwork. This young lady must be checking the time. The children were certainly not allowed to set or wind the clocks.

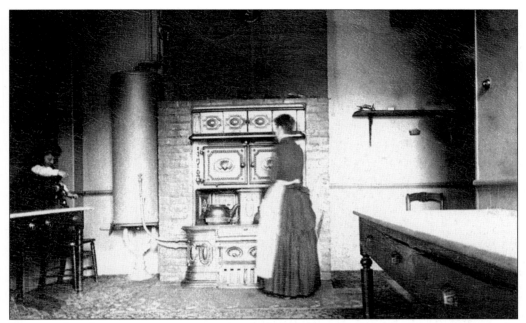

Photographs of service areas are rare, but Isabel Drake must have been pleased with the household's up-to-date oven and range. Surely, it was much cooler and more convenient (not to mention more compact) than a wood stove.

This horse-drawn fire pumper, a little girl's pull toy, would be a valuable collector's item today.

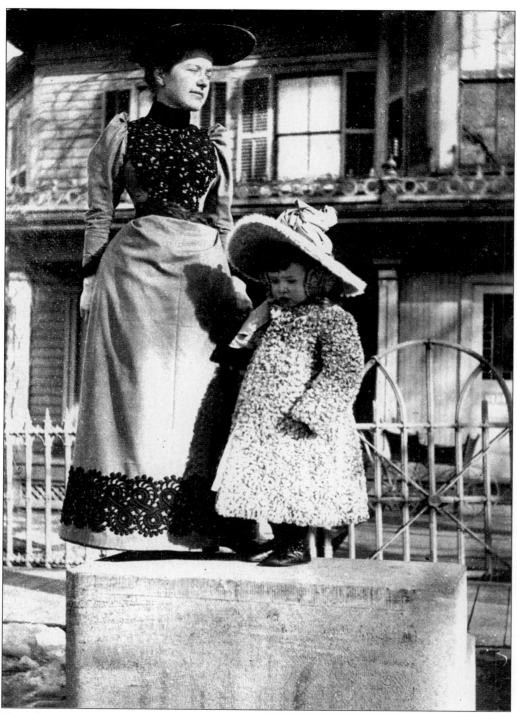

Note the elaborate appliqued lace on Mother's dress. A doll carriage (or baby buggy) can be seen through the gate at Grandfather's house. Home, however warm it may have been, was only the starting point for the Drake clan.

Two
AROUND TOWN

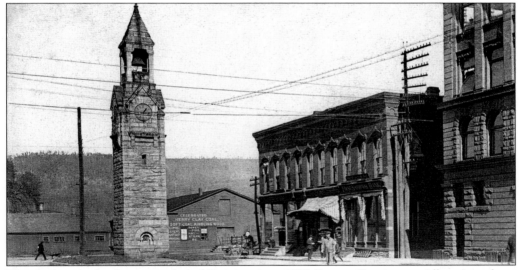

The clock tower has been a symbol of Corning since 1883. Erastus Corning, an Albany merchant who developed the real estate, never visited the town that bore his name. The tower was a gift from the family in Erastus Corning's memory. In 1890, the villages of Corning and Knoxville (the Northside), with a combined population of 10,000 people, formed the city of Corning.

Now called Centerway, the square at Pine and Market Streets is still a hub of activity for residents and visitors alike. In this view, James Drake's First National Bank is to the right. Note the unsightly array of utility poles and wires. The post office was also in that building. Coal and accessories (in the background) were big business, of course. Canal boats had formerly docked here on the Chemung River.

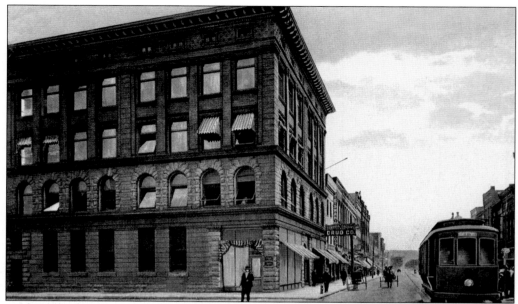

First National later moved a few steps to the busy corner directly on Market Street. The printer of this postcard sanitized away the overhead wires, including the one that powers the streetcar.

Brick paving on Pine Street bespeaks prosperity (and a local brick works) in this view taken from First Street looking north. An automobile on Pine is upstaging the horses on Market. Notice the posters on the building to the left.

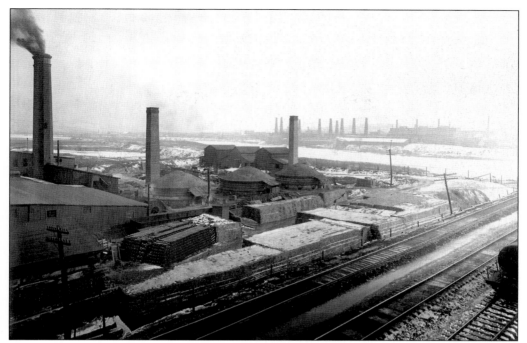

This is where the bricks were made. The stacks in the background are at the glassworks on the Southside. People arriving in industrial towns back then often cried, "Ah! Smell that smoke!" Smoke meant work and wages.

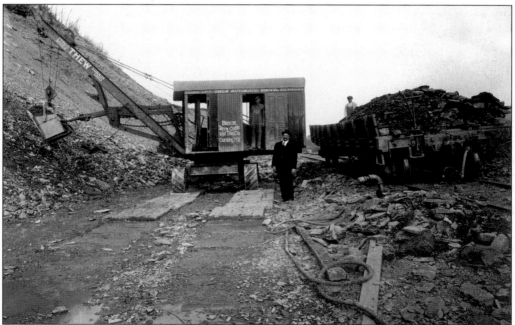

What on earth is powering this shovel at the brick works? There seems to be no exhaust for a steam boiler or even for an internal-combustion engine. Notice how the platform planks have clearly been edged back to follow the shovel's progress.

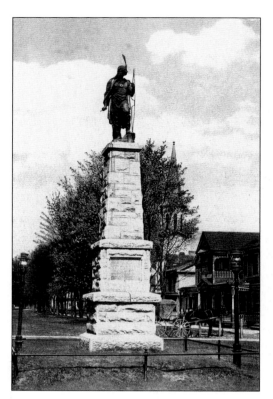

The adjoining village of Painted Post took its name from a Seneca marker on the site. This monument at Water and Hamilton Streets was replaced and relocated after a lightning strike. The metal Native American figure (a catalog item) is at the depot museum, along with two metal Native American wind vanes that topped earlier posts on the spot.

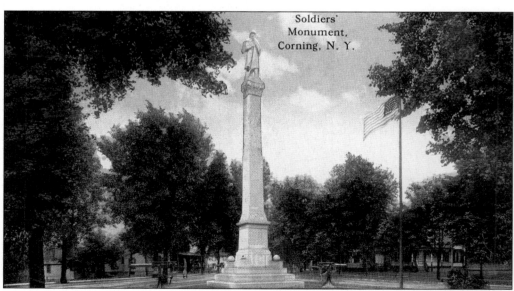

Soldiers' Monument, Corning, N. Y.

The Civil War memorial still graces Corning's Park Avenue, but the surrounding neighborhood, along Denison Park, has become a byway. The weaponry, perhaps used for World War II scrap drives, is gone.

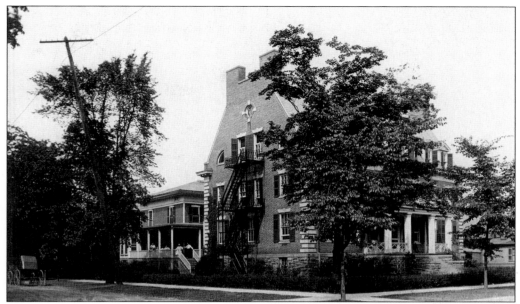

Corning's new hospital was the pride of the city. The current Corning Hospital is at the same First Street location, but the original building (after many expansions) is gone.

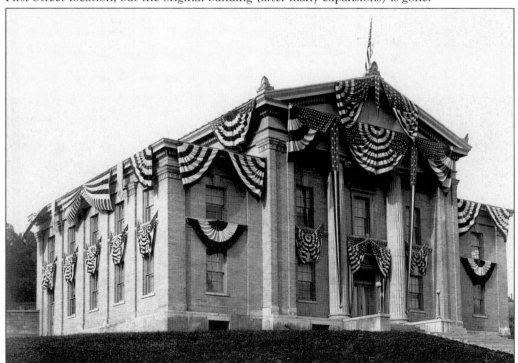

In this Hewitt photograph, the Steuben County Courthouse, on First Street, is decked out for the Central New York Volunteer Firemen's Convention, held between July 25 and 29, 1905. Steuben County is somewhat unique in that, because of its size, it has three county courthouses—in Corning, Bath, and Hornell.

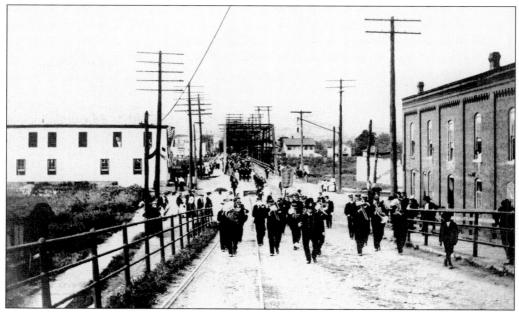

The firemen at the 1905 convention paraded on Bridge Street. They are seen here starting up the viaduct that went over the railroad tracks. The tracks for the Corning-Painted Post Street Railway can be seen on the left side of the viaduct.

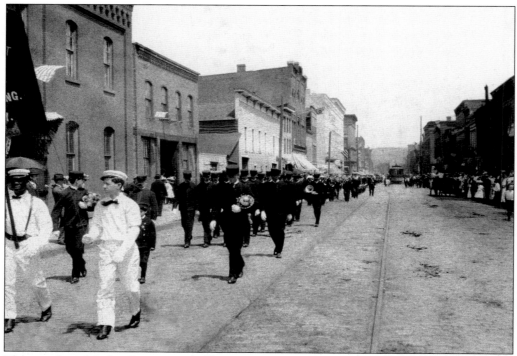

This parade on Market Street is probably not part of the 1905 convention, as the participants are marching in the opposite direction. This view appears to be looking east from Chestnut Street.

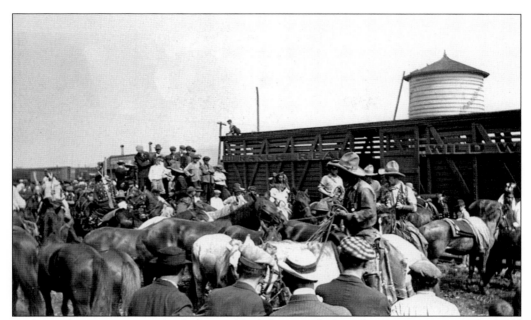

Dudes in their snappy eastern clothes mobbed the arrival of "authentic" westerners. The Wild West was already a subject of legend and fantasy by the time the century made its turn.

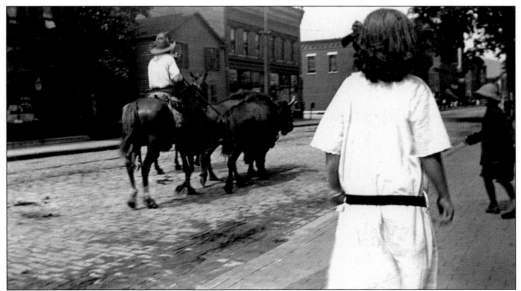

This was probably the last time anyone drove buffalo through the streets of Corning.

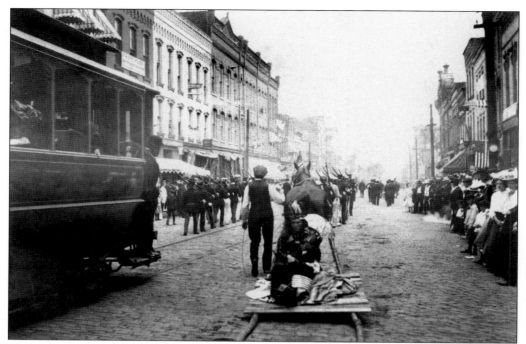

The travois in this photograph by Hewitt (a prominent local photographer) may have been part of the Wild West show pictured on the previous page. The trolley is either part of the parade or is waiting for it to end so they can proceed.

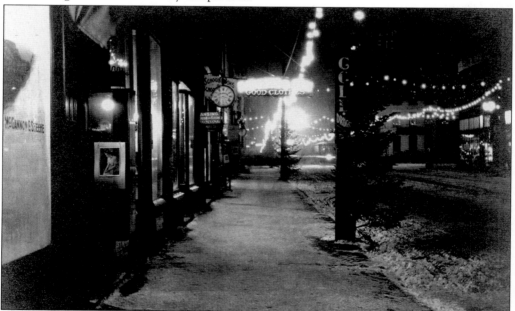

Market Street celebrates "Sparkle" each year to kick off the Christmas shopping season. It looks like they had the concept as far back as 1910. Note the streetcar just to the left of the Gold Drugs sign. The horizontal streak of light (from the streetcar's bull's-eye headlamp) suggests a time exposure.

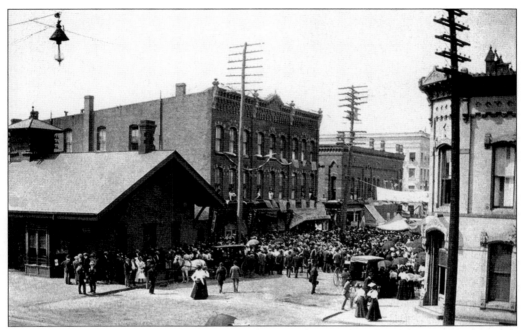

The reason for the crowd seen in this 1900 photograph is a street fair. The view looks north from across Erie Avenue at Pine Street. The Erie depot is the building on the left.

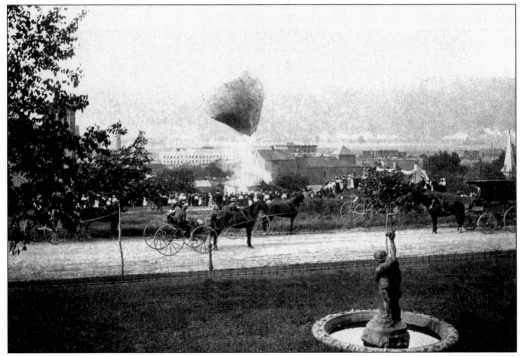

The same street fair may have been the occasion for the launch of this unmanned hot-air balloon. The vantage point appears to be Third Street. The steeple of the Presbyterian church is visible at the extreme right, and Corning Free Academy is on the left.

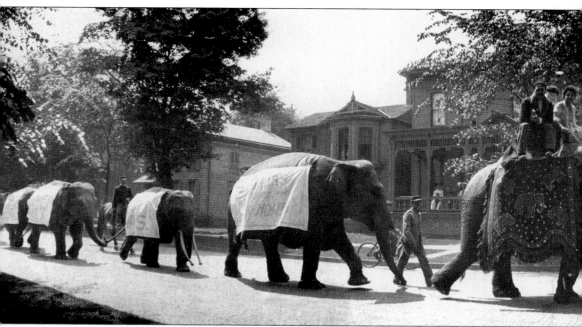

A circus parade on First Street was an obvious must for Isabel Drake. The folks in the howdah

Corning sometimes hosted several circuses or other traveling shows in a single summer. These

seem more excited by the panoramic camera than they are by the elephant.

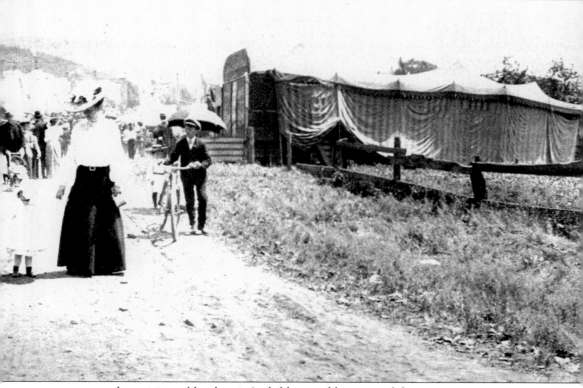

events were eagerly anticipated by the city's children and by some adults.

Dort Drake and her cousin Glen Cole took advantage of a handy horse block to watch a circus parade.

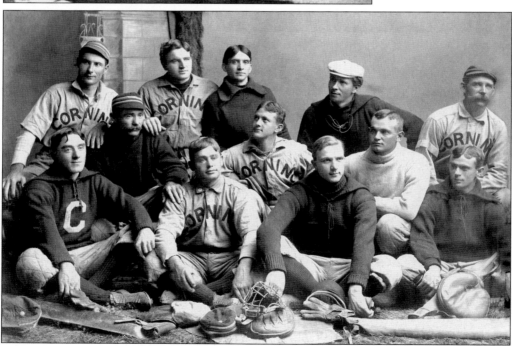

Next stop: Cooperstown. Corning baseball teams crisscrossed the region by rail, sometimes boarding steamboats or stagecoaches to reach their more remote opponents. Note the quilted leggings.

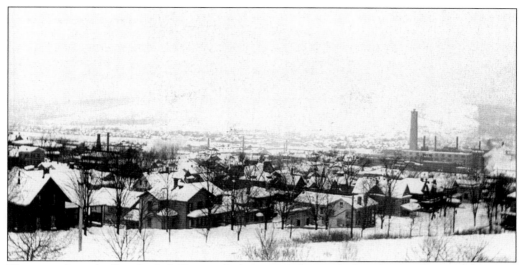

This view from the Southside hill is much the same today, including the "Little Joe" shot tower at the glassworks. The tower, used for making thermometer tubing, is the only Main Plant structure remaining today.

The 1856 arsenal on West First Street in later years became an extremely imposing convent for the St. Mary's parish. It is now the site of Castle Garden Apartments. The state forgave half of the St. Mary's purchase price, perhaps inspired in part by the pastor's friendship with Gov. Grover Cleveland.

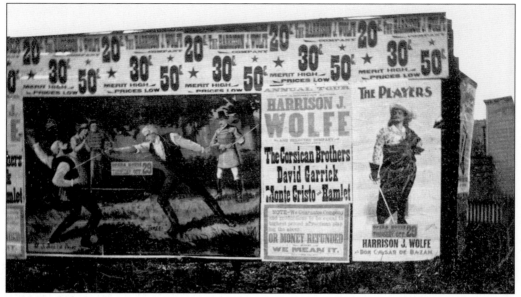

Eighteenth-century actor-playwright David Garrick is largely forgotten today, but his work was still wildly popular in November 1896. The artistic Drakes were enthusiastic patrons of theater and concert hall. On at least one occasion, they traveled to hear Caruso.

Harrison J. Wolfe certainly seems to have struck a chord, judging from the way Isabel Drake cut this photograph to shape. She anticipated many of today's popular scrapbook techniques.

Mossy Glen, now South Corning, is a little more built up these days. This photograph was taken from a well-known local tower.

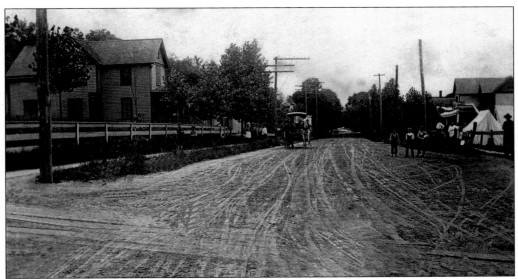

Gibson must have been a busy place, judging from the tracks in the road. At the time of this *c.* 1900 image, the appearance of a photographer should not have drawn a crowd.

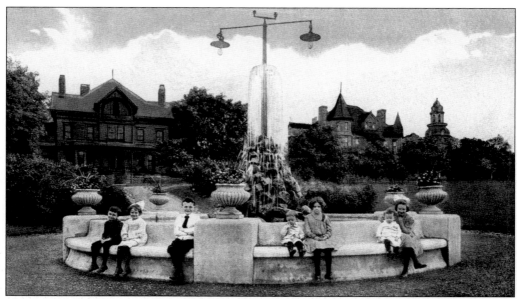

Beyond this fountain at the courthouse are the Hawkes home, the Drake home, and the old Corning Free Academy. This card was postmarked by the New York and Salamanca Rail Post Office.

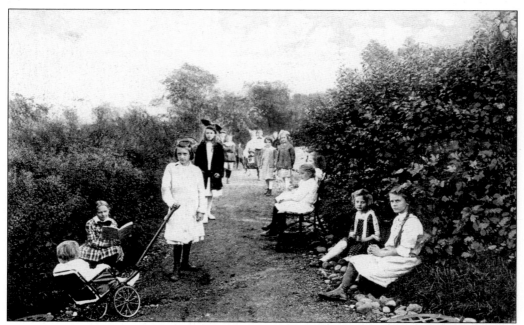

If these expressions are any guide, the Courthouse Park was not much fun. It appears as if a postcard photographer has gathered these children just for the photograph.

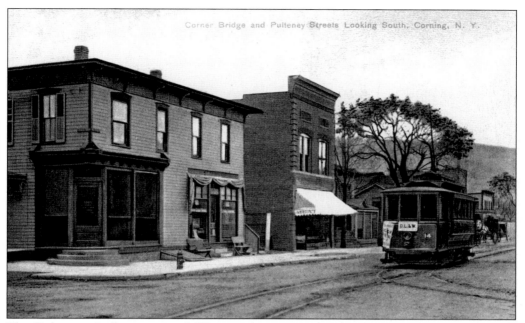

The Delaware, Lackawanna and Western depot must be the destination of this streetcar traveling south on Bridge Street, about to cross Pulteney.

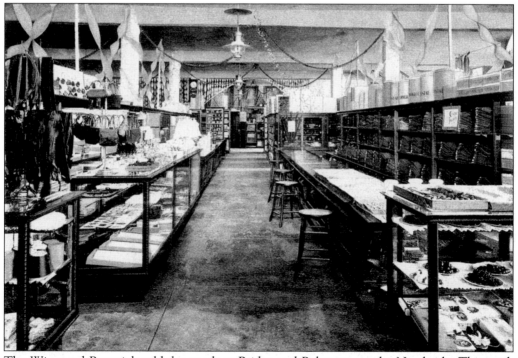

The Wing and Bostwick sold dry goods at Bridge and Pulteney, on the Northside. This card, sent from R.E. McBurney to Josephine Shafer, was postmarked in both Corning and Dundee on Christmas Day 1909. Postal workers' unions were only a dream.

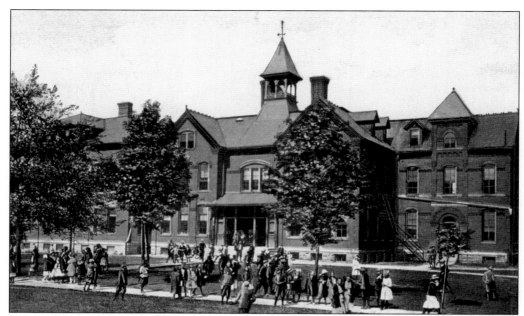

Northside Grammar School, pictured in this postcard, was a source of local pride. Schools in most towns were a popular subject for postcards.

Ed Green was the Drake family's hired man for many years. Corning Free Academy, another source of local pride, is visible in the background.

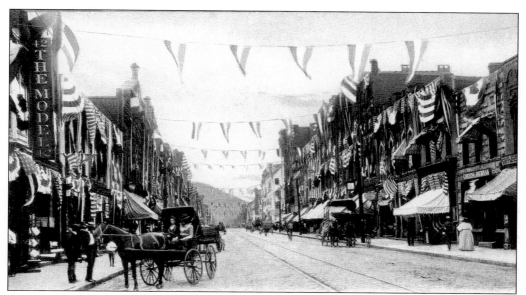

A caption on this Market Street photograph reads, "A gala day." The Model Store (left) was a popular department store. The *Corning Journal* (right) was the Republican paper, in opposition to the *Corning Democrat* (now the *Corning Leader*).

The Greig dry goods store, on the north side of Market Street between Walnut and Pine Streets, became Rockwell's. Bob Rockwell had so much Western art displayed in his department store that he moved it to a museum in the old city hall. The Rockwell Museum is now a major attraction.

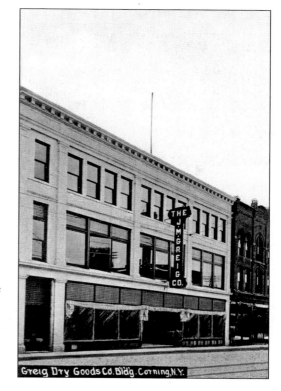

Greig Dry Goods Co. Bldg. Corning, N.Y.

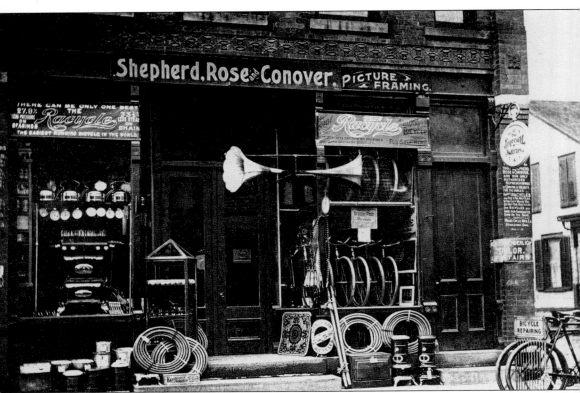

"You and your friends are always welcome at our store, drop in any time and hear the latest music free." Shepherd, Rose, and Conover (at 107 Bridge Street) ordered these postcards from Germany. It appears from the signs and the merchandise displayed that the establishment offered many products and services. This is now the site of the Northside Flower Shop.

The corner doorway to the right (on Market and Cedar Streets) now leads to the Manhattan Bagel Bakery. The large block down the street appears to be under construction; there are no windows.

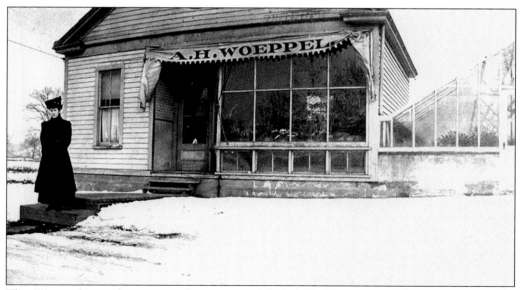

The Woeppel greenhouse must have counted Isabel Drake among its best customers. She usually had fresh flowers in her home.

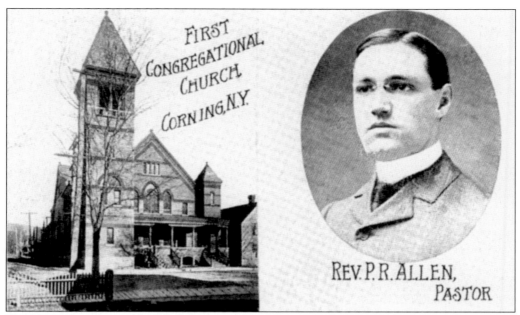

The First Congregational Church was on Bridge Street on the Northside. Part of the building remains and is used as offices.

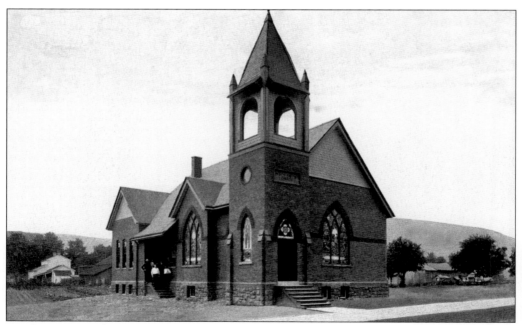

North Baptist Church, which has had several additions, is still a gospel center. The neighborhood is much more built up now.

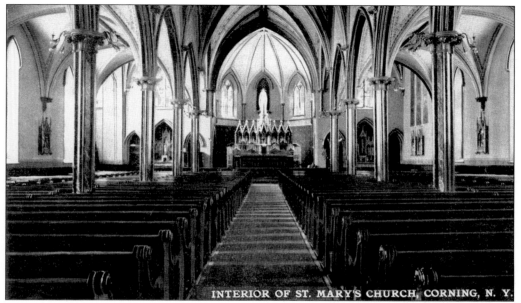

Several Catholic churches served Corning and the surrounding area. St. Mary's was the largest and one of the oldest.

St. Mary's and its school built an impressive new convent after giving up on the arsenal. (See page 47.)

St. Mary's and the school dominated the western end of "the Hill." Riding a sled down Walnut Street must have been exciting.

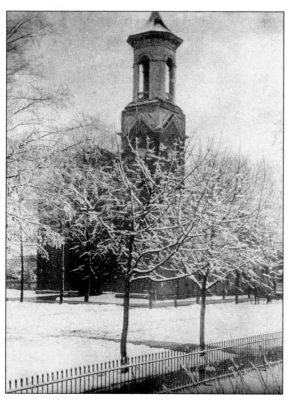

In 1894, this Methodist church building on First Street was replaced by the present structure. Viewed from across Cedar Street, it certainly makes a beautiful image with the snow.

The Presbyterian church, at Pine and First Streets, is an impressive edifice. It is one of three stone churches on First Street.

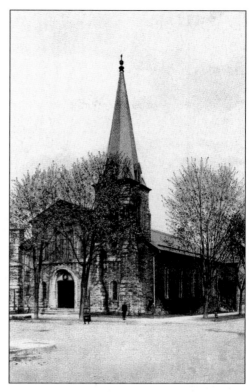

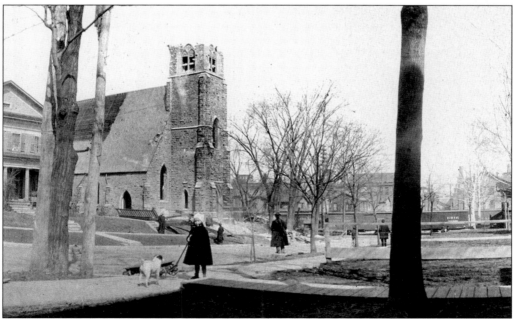

The former Christ Episcopal Church, on Walnut Street, later became "the German Church." The Erie Railroad ran right down Erie Avenue, now Denison Parkway. The post office occupies the site today.

Methodist Church, Painted Post, N.Y.

Mr. and Mrs. D. Van Etten mailed out this postcard on August 18, 1909, cordially inviting visitors to spend an evening at home on Thursday from 8:00 to 10:00 p.m.

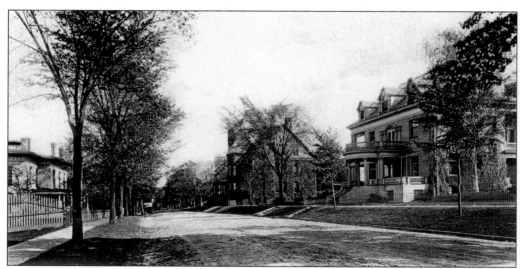

Arthur Houghton made his home in the large house on the right in this view of Third Street as seen from Walnut Street. The Houghtons still head up the glassworks (now Corning Incorporated), and a former chairman holds the congressional seat. The home is now the College Center of the Finger Lakes. Today, Corning Free Academy is across the street.

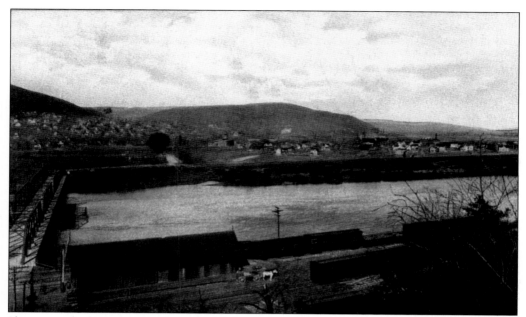

If you were looking west in Gibson in 1890, this is what you would have seen of Corning. The tracks of the Delaware, Lackawanna and Western Railroad are in the foreground. Prior to the railroad, a canal lock was in this area known as "the Chimney Narrows."

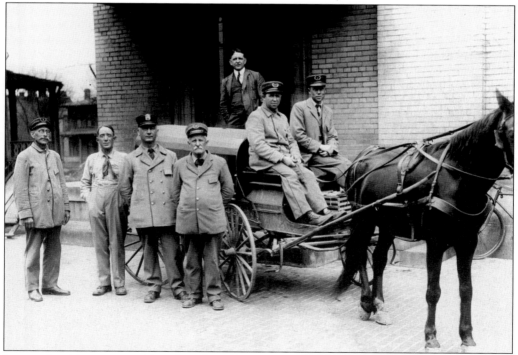

It must have been an exciting day when Corning got its first parcel post wagon. From left to right are Fred L., Charles ?, George Veith, John McAvoy, Wilfred ?, and ? Guntrop. The man in the back is identified as Mr. Ginnane.

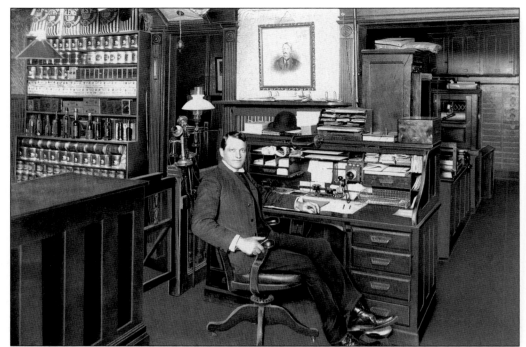

C.R. Maltby, grocery wholesaler, looks quite professional in his office until you notice that he is propping his feet on his cuspidor. He has two wand telephones behind his shoulder, and an even older model (perhaps part of an internal communication system) is built into the upright back of his desk. At times, there were competing telephone systems in town, so the two wand units may be connecting to completely different customers.

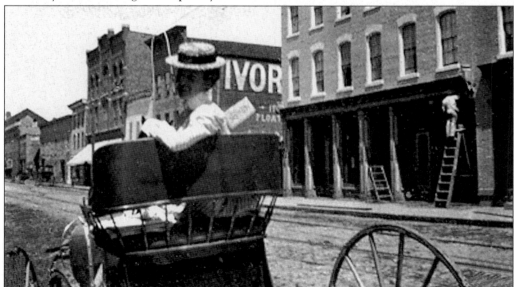

Careful searchers can still make out traces of wall art advertising in Corning, but the Ivory soap advertisement is long gone. The stores shown in this photograph are on the north side of Market Street.

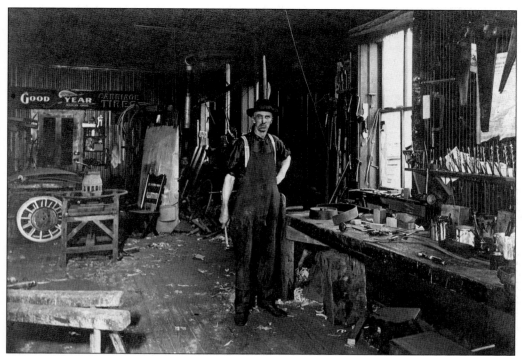

H.W. Wheat, seen on August 9, 1911, in his shop at 86 Wall Street, appears ready to tolerate no nonsense at all. On the rear wall is an advertisement for Goodyear carriage tires.

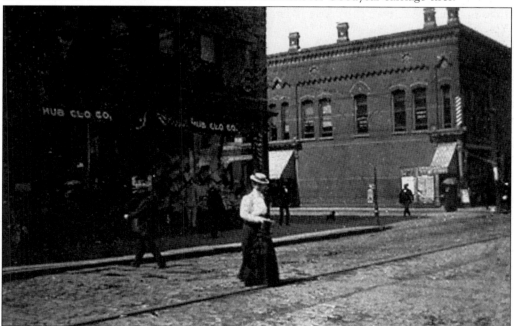

In 1899, the Hub Clothing Company was a popular emporium. It continued in business on Market Street (farther west) into the 1970s. Note the barber's pole on the second-floor corner, across Cedar Street.

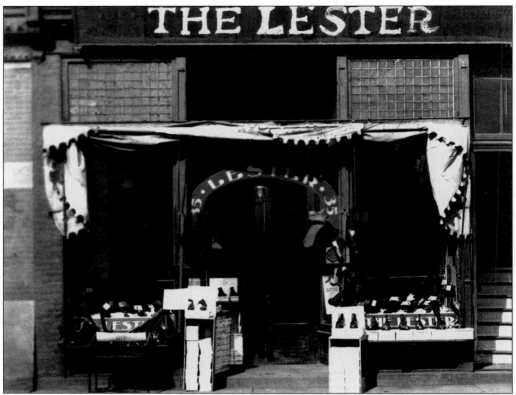

The Lester sold shoes on Market Street for years. Notice that most of the shoes, for men and women alike, are boots or high tops.

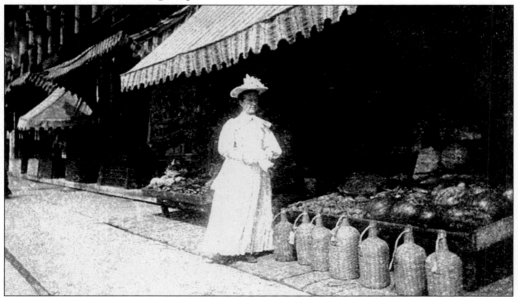

All that wickerwork, once a routine of everyday life, is now an exotic antique craft. Unfortunately, there are no longer any grocery stores on Market Street.

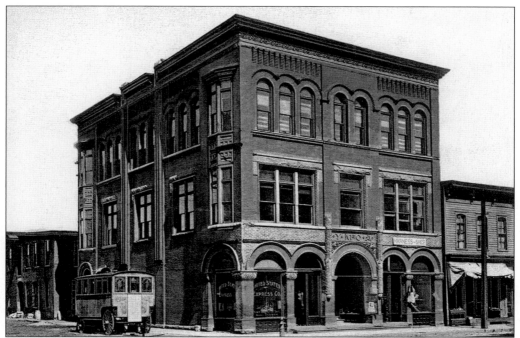

The old YMCA sported a harness shop and express agency on the ground floor. Outside was a lunch wagon. The building still stands (without its third floor and with a complete new facade) on the northeast corner of Market and Cedar Streets.

The Odd Fellows building, on Erie Avenue, was located near the Erie depot to better serve traveling young men. There was even a dentist in the building.

This well-kept buggy in front of the Corning Hospital is matched by its sleek, well-groomed

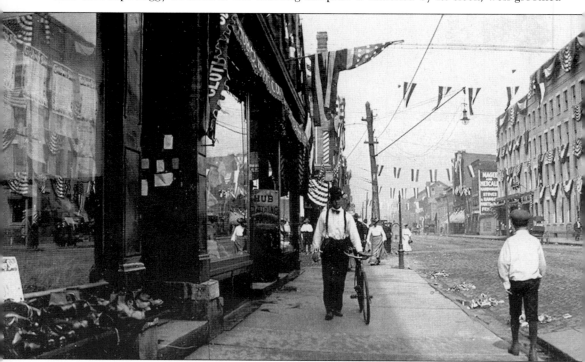

The bustling, fast-growing nation was enthusiastically and unashamedly patriotic. In this view, the New York Central station (just to the left of the clock tower) is gone, and the Dickinson House hotel (with all the bunting) has been replaced by the Baron Steuben Building, home of

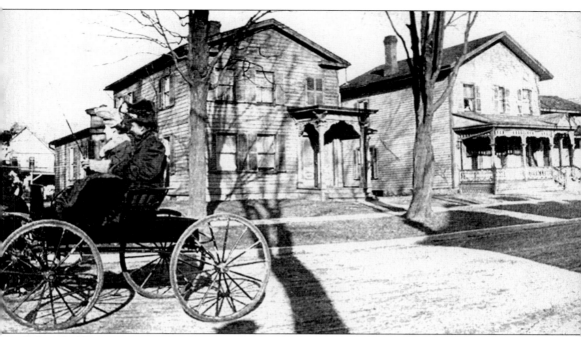

bob-tailed bay.

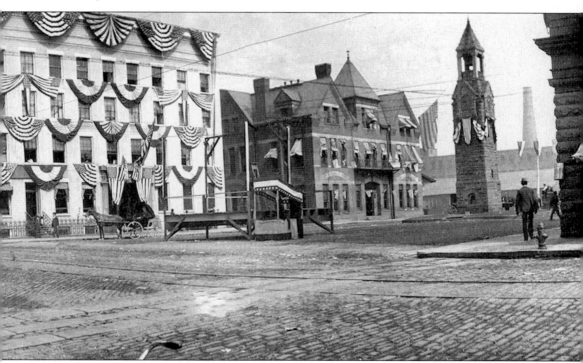

the visitors' information center. The current stage for special events is just a few steps to the right of the platform. The two corner crosswalks are in much the same place.

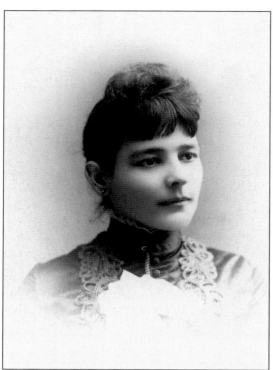

Kate Goodrich taught at the one-room school (still standing) in the hamlet of Curtis. This is an albumen print.

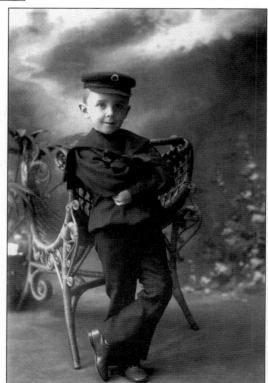

This jaunty gent is identified only as a member of the Curtis family (of Curtis). He seems to have no qualms about posing.

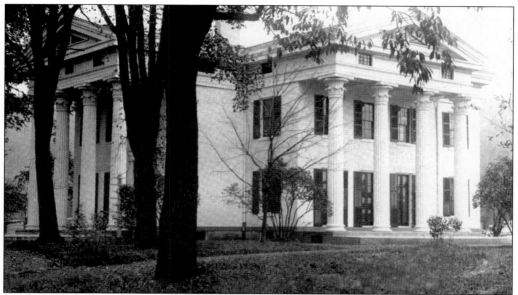

The Imperial Club had an edifice befitting its name. At one time, it was the recreational facility for the Ingersoll-Rand Company.

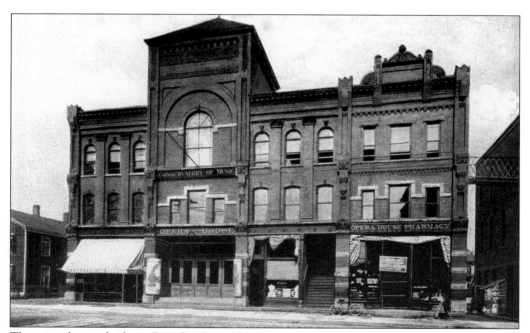

The opera house, built on Pine Street in 1891, was an exciting hub for the city's artistic crowd. Prof. John C. Bostlemann, the Drake girls' tutor, ran the Corning Conservatory of Music on the second floor.

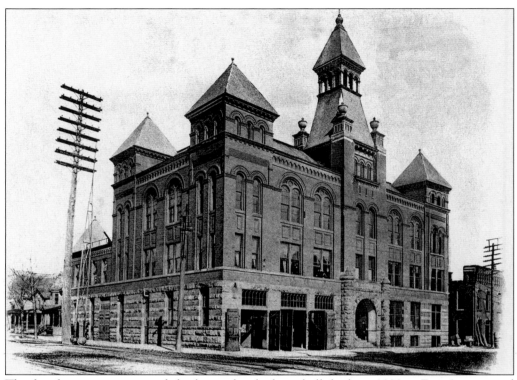

The fire department occupied the lowest level of city hall, built in 1890 at Erie Avenue and Cedar Street. This fine city landmark is now the Rockwell Museum of Western Art.

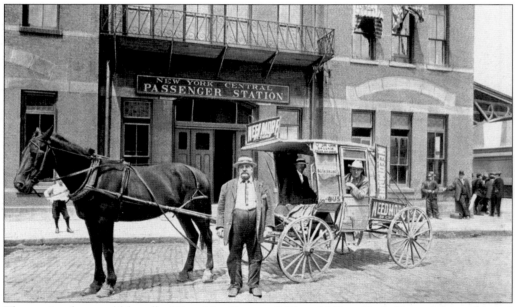

The station bus could handle "U or Ure Baggage." The old New York Central depot fronted what is now Centerway Square.

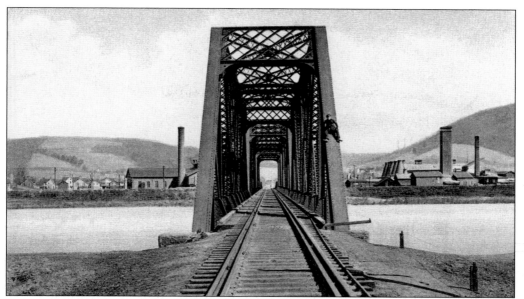

New York Central engineers no doubt hated the added risk posed by small boys climbing the bridge (look halfway up the right buttress). The brick works can be seen across the river on the right.

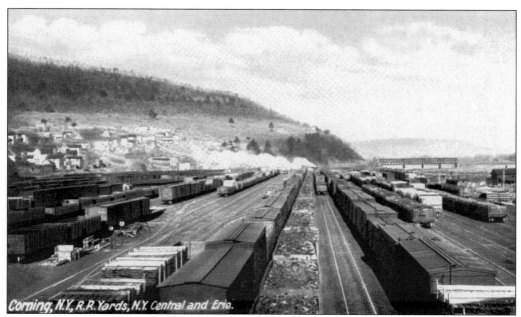

Corning, N.Y., R.R. Yards, N.Y. Central and Erie.

Corning still has a major rail yard (now Norfolk & Western), but it is located a little farther out of town in Gang Mills.

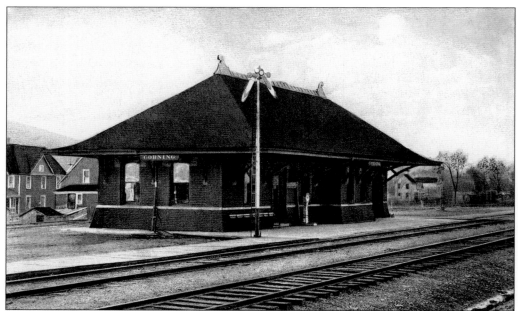

This postcard view shows the Delaware, Lackawanna and Western depot on the Northside. You can see the Delaware, Lackawanna and Western tracks in the background of the skating scenes on pages 74 and 75.

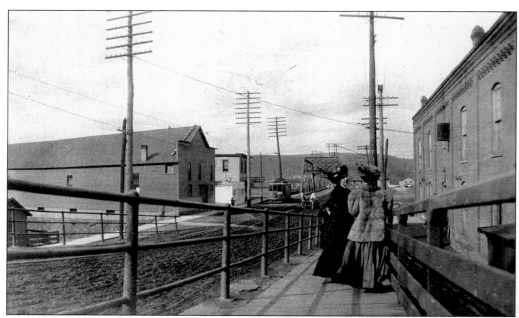

The trolley and the horse-drawn dray are both trundling south on Bridge Street and heading toward Market Street. The bridge over the Chemung has been replaced, and the viaduct and all the buildings shown on this side of the river are gone.

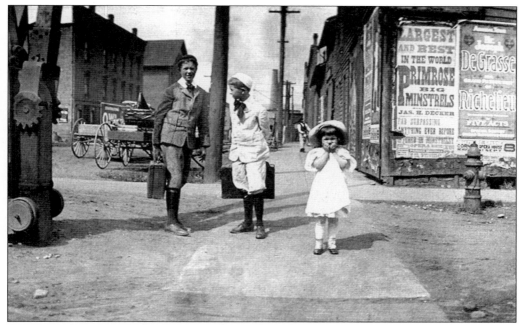

On September 1, 1905, the cousins of the Drake girls are eager for what may be their last trip to the lake for the summer. Notice the posters for the minstrel show and the stage play, both booking into the opera house.

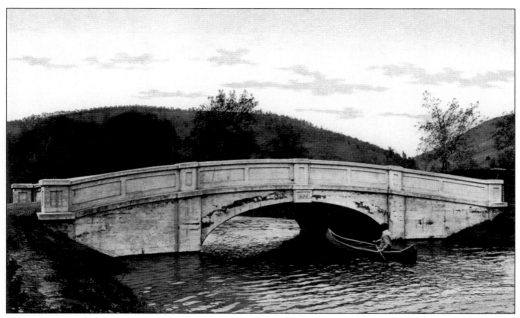

Local folks will recognize the bridge in Denison Park, but canoes are an uncommon sight there today.

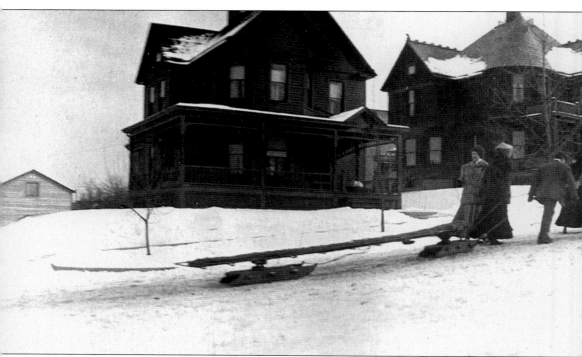

Bobsledding is not seen on Corning's streets today; it is much too risky for our safety-conscious

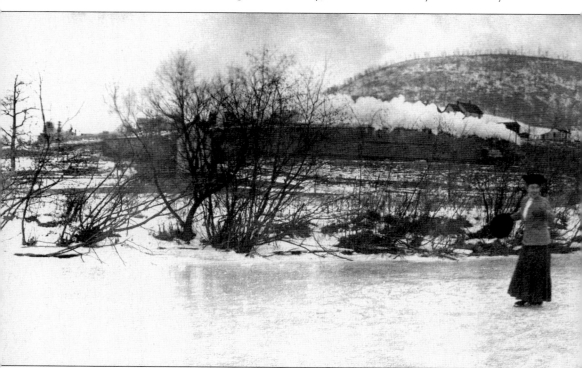

Women and men alike enjoyed skating on the Chemung River and the streams in the park. The

times. Imagine the protests if the streets were left unplowed, let alone filled with sledders.

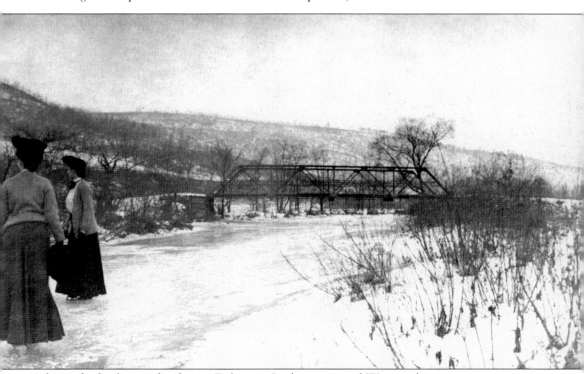

smoke in the background is from a Delaware, Lackawanna and Western locomotive.

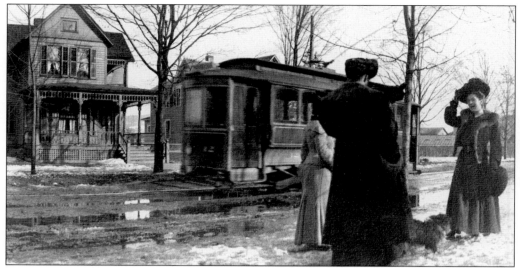

With the sloppy streets and those long dresses, the ladies should have taken the Corning-Painted Post Street Railway passing by.

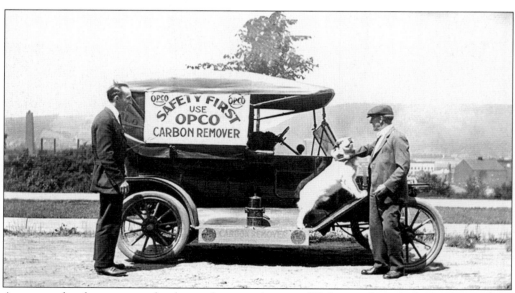

A new technology spawned a host of new industries. With paved roads being few and far between, that black car must have been difficult to keep shiny.

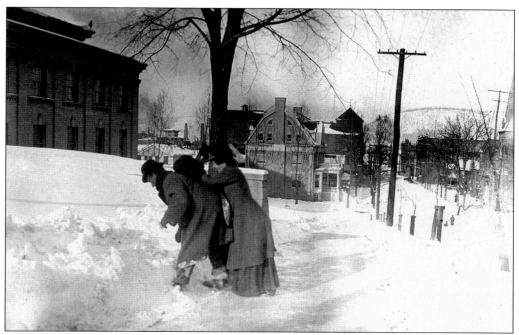

The Drakes are seen clowning in the snow on Pine Street beside the courthouse, with the "old library" at the center.

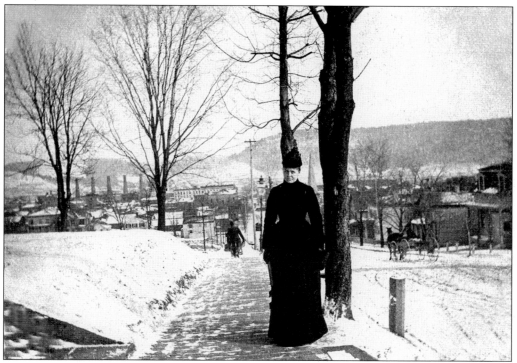

The Southside's hilly streets can still be a challenge with snow underfoot. Imagine having to manage them with a horse-drawn conveyance.

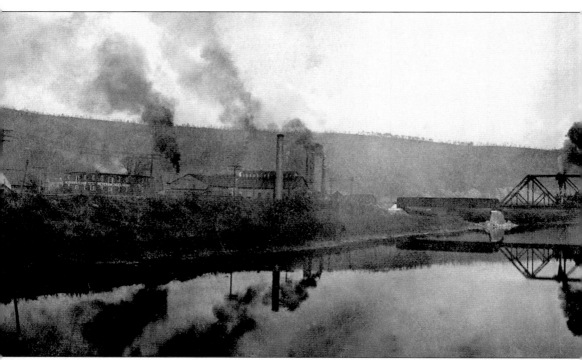

Isabel Drake skillfully used reflections to turn what could have been a grimy industrial image into an appealing piece of art. The brick works can be seen to the left. The glassworks is to the

Carriage houses became garages as time went by. Notice the ornate scrollwork over the doorway

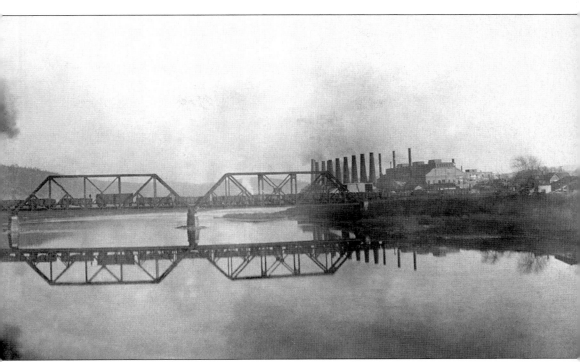

right, on the south side of the Chemung.

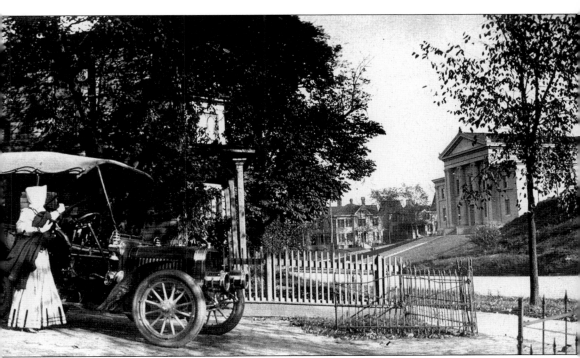

to the left and the courthouse to the right. This area is now the parking lot for the Corning Elks.

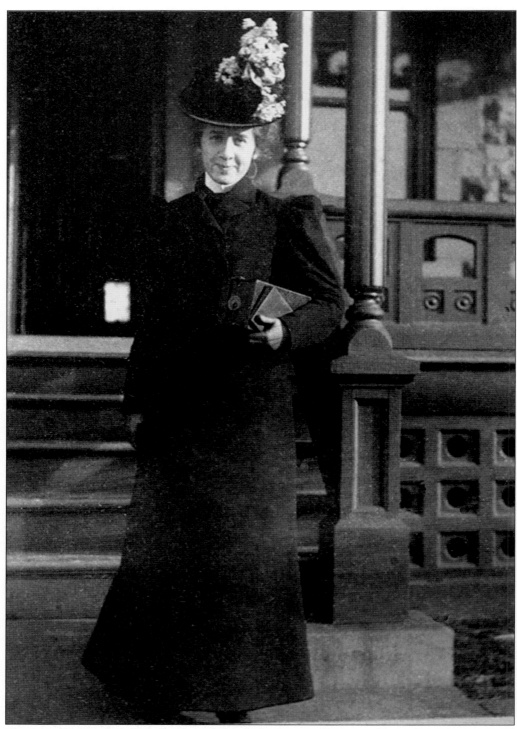

The front door on Isabel Drake's home opened both ways. She carried her magic mirror around the town and across the continent.

Three
IN THE GLASS BUSINESS

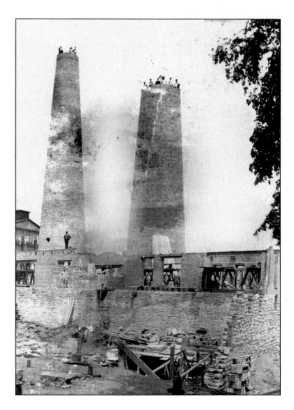

Coal and railroads lured Brooklyn Flint Glass (soon Corning Glass) to town after the Civil War. That move quickly reshaped the town, spawning spin-offs while attracting competitors and ancillary businesses. Even today, when Corning Inc. focuses mainly on fiberoptics and telecommunications, local folks routinely describe it as "the glassworks."

Glass arts became so prevalent that Corning, by the Gilded Age, was already known as the Crystal City. However, it was industrial production (much of it for railroads) that fired the glory holes of the 19th century, along with the glass furnaces shown here under construction. As World War I cut off German imports, new markets developed for labware (made with Corning's brand-new Pyrex) and Christmas ornaments.

Numerous firms and myriad shops have come and gone, but for a century and a half, Corning's fortunes have risen and fallen with those of Corning Glass, now Corning Inc.

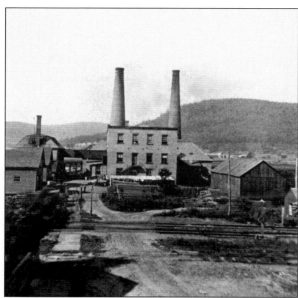

The completed plant meant new work and new business. This area eventually became known as Main Plant, to the north of Market Street, and held the entire company until the 20th century.

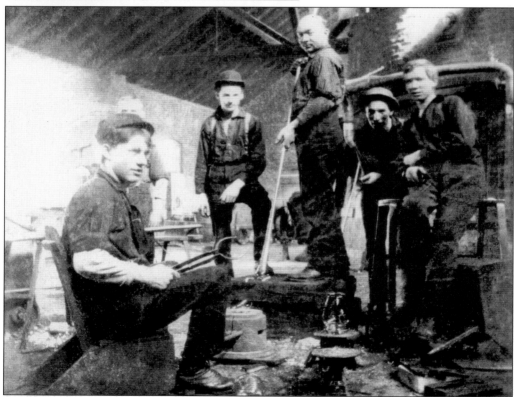

If plutocrats like the Drakes and Houghtons ruled high society on the Hill, the highly skilled gaffers were revered as the pinnacle of industrial life on the Flat. Standing tall with his blow iron, this gaffer is undisputed king of his "clean iron shop." Workers were often German or Swedish, leading to the generic label "German shops." This crew is making railroad lanterns.

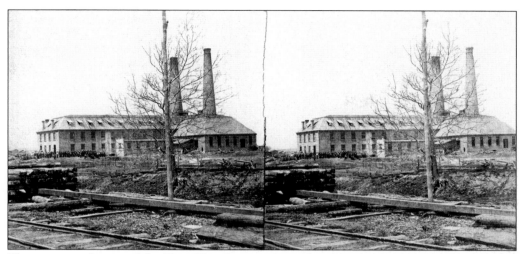

This stereograph view of the Flint Glass factory was produced by the A.D. Jaynes Photographic Rooms. Note the crew just visible at the lower left of the building.

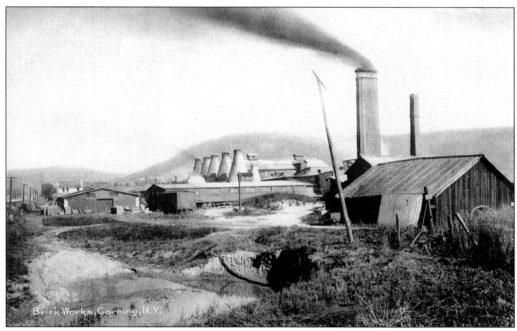

Glass was only one aspect of Corning's prosperity, of course. The brick works was a major employer, while other city firms rolled cigars from locally grown tobacco.

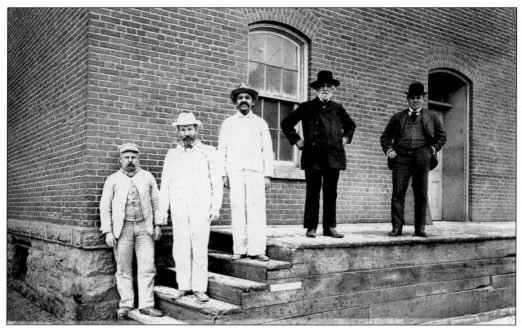

This photograph was taken *c.* 1880 at the Hayt Mill. The crew includes, from left to right, ? Lockwood, E.L. Conklin, Sam Dickinson, D.J. Hayt, and Towner Hayt. Located at Walnut and Market Streets, the mill was later acquired by Corning Glass and is still known locally as "the Clubhouse."

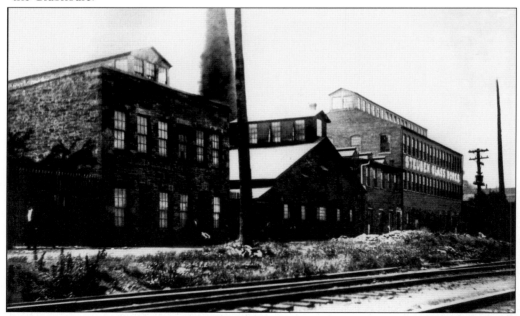

Frederick Carder developed new ways to fix colors in glass and new styles in which to shape it. The new "Steuben Ware" remains highly prized more than a century later. Carder's son Cyril died in World War I. The central portion of the Steuben plant above, on Erie Avenue, was originally the Payne and Olcott Foundry.

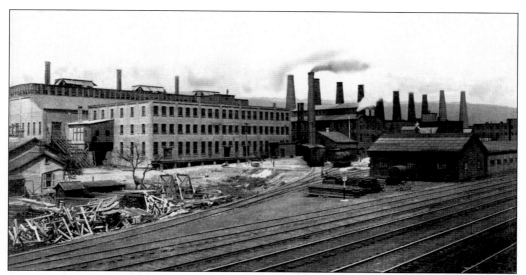

Compare this *c.* 1910 view with the one at the top of page 82. The business grew. Most of these buildings were part of the Main Plant complex when it was demolished, but there was only one set of railroad tracks left in use.

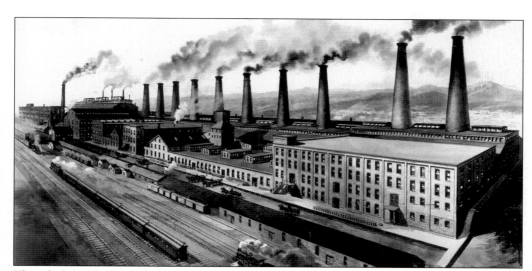

This slightly idealized view, looking west from Pine Street, still gives an impression of the clouds of smoke produced by such a vast facility.

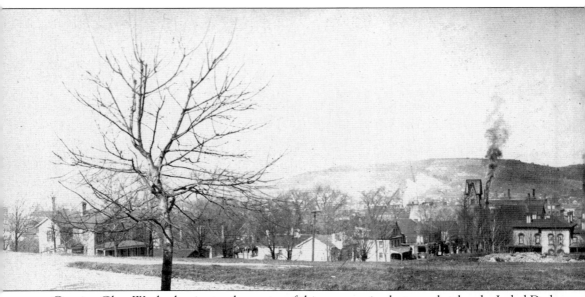

Corning Glass Works dominates the center of this panoramic photograph taken by Isabel Drake

Enlightened firms like Corning Glass often sponsored company bands, debating societies, sports teams, and similar organizations. You would think that Armistice Day (the first

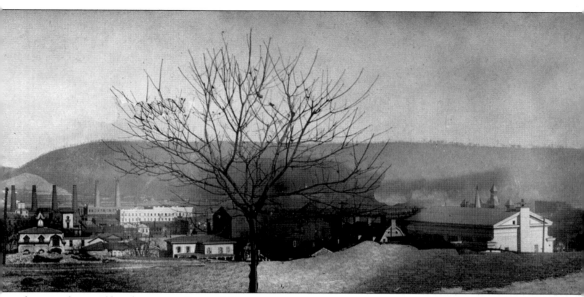

from in front of her house on Second Street.

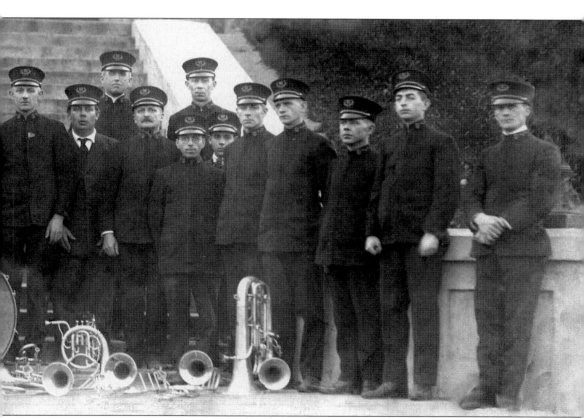

one, November 11, 1918) at the courthouse would spark a little more enthusiasm.

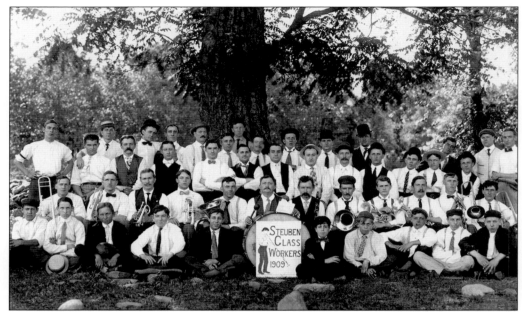

Corning Glass eventually absorbed Steuben Glass, but in 1909, Carder's hands could still proudly contrast their work as artists with Corning's industrial operations. This outing took place at Hodgeman's Dam in Painted Post.

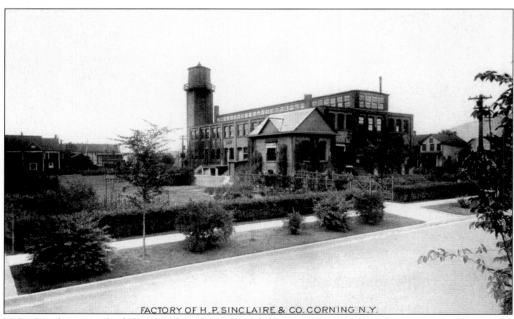

H.P. Sinclaire worked for Hawkes Cut Glass before striking out on his own. Son Reginald Sinclaire, who often motorcycled to Hammondsport to watch airplane flights, joined the U.S. Air Service for World War I. He shot down four German airplanes.

Four
OUT AND ABOUT

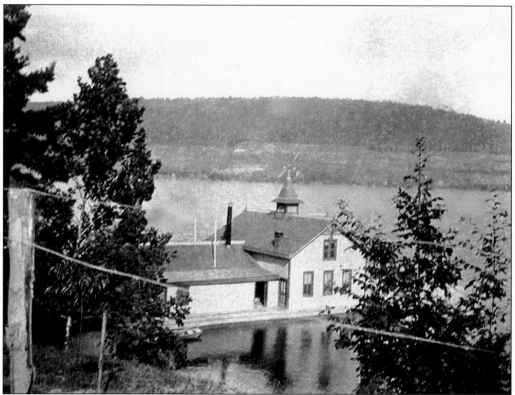

Well-to-do Corning families had their summer retreats on Keuka or Seneca Lakes. In fact, one lakeside colony on Keuka was so popular that it came to be known as Corning Landing. The Drakes, better off than most, established Drake's Point, which still bears their name. Two huge "cottages," a two-story boathouse, an extensive shoreline and a breathtaking view created a setting still worthy of envy.

However, even the Finger Lakes could not contain the Drakes. As their children were growing up, they visited two world's fairs, explored the American West, summered on Long Island Sound, and toured around Philadelphia. The world was their oyster, and Isabel Drake's camera was their scribe.

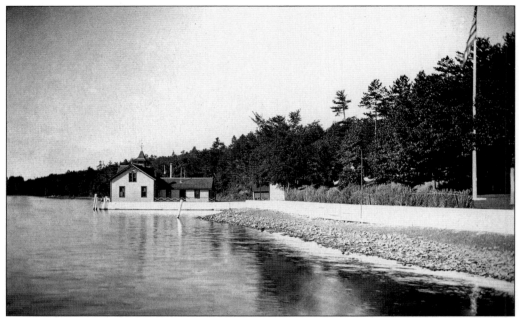

Drake's Point, captured in these side-by-side photographs, was a spacious complex on the west shore of Keuka Lake, opposite the tip of Keuka's Bluff. The boathouse, on the south end of the property, was demolished and became part of more than one cottage.

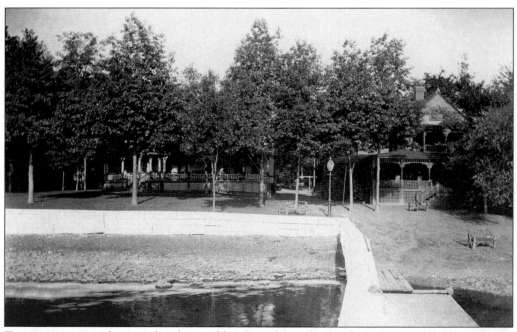

Two "cottages" made space for plenty of family and friends. "Madge's Cottage" (left) is now the Lakeside Restaurant. After James Drake's fortune was lost in the Panic of 1913, the point became an amusement park complete with a soda-drinking bear.

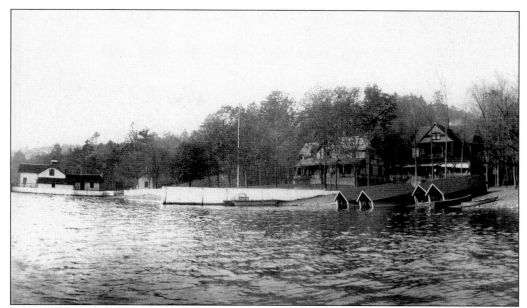

Smaller boathouses, open at each end, handled the lesser craft. The *Madge* and the *Ogontz* were kept in the large boathouse, which is also where the steamboats docked.

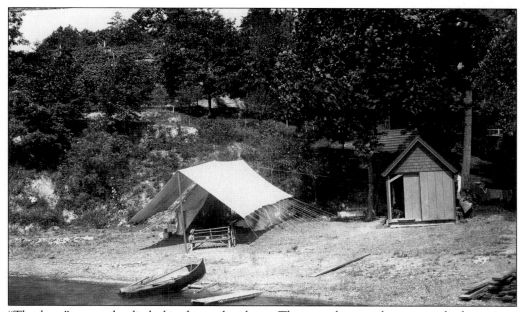

"The boys" camped a little bit down the shore. The complex was large enough that it was almost like they were alone at the lake.

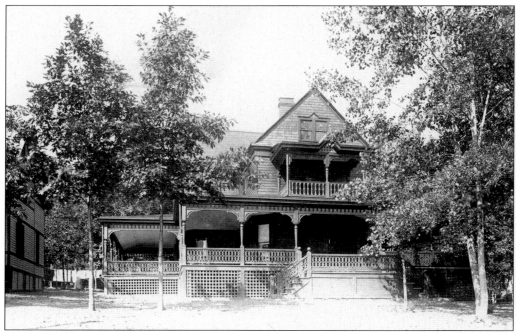

Inside the trees we get a better view of the main house, with its gorgeous wraparound porch. Madge's Cottage is to the left.

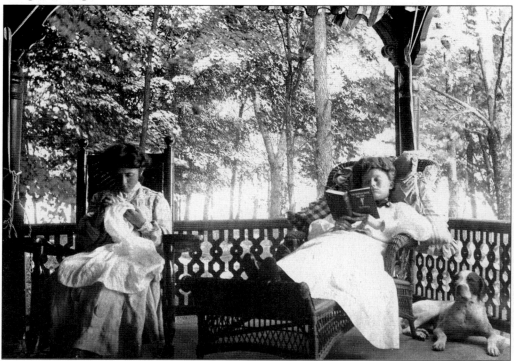

That porch was an ideal place to while away the summer. Porches were very fashionable at that time. Unfortunately, most have been removed today.

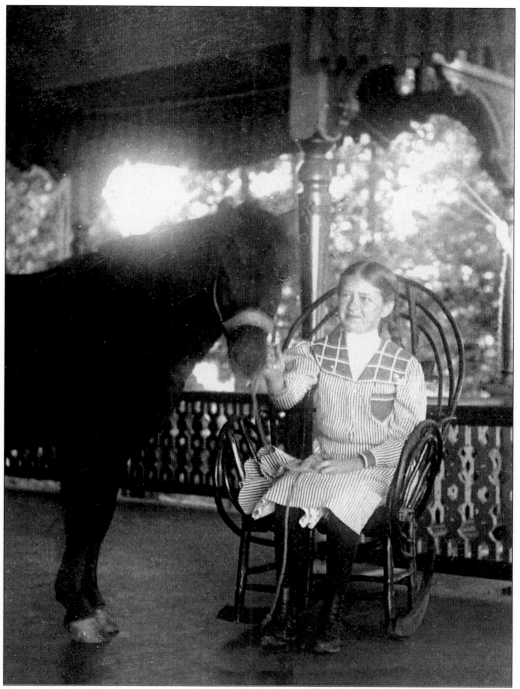

You could even have your pony for a visit. Porches should be the theme of these two pages. They remain on both cottages today, although the one at Madge's Cottage (now Lakeside) is enclosed.

Are the girls dreaming or enduring one more pose at Mother's insistence? In either case, this photograph represents another of her great compositions.

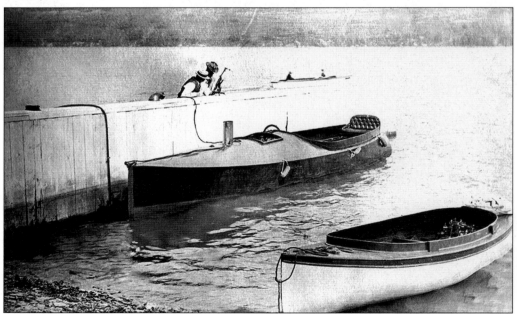

Getting to the lake meant changing trains at Bath to the end of the line in Hammondsport. Here they were met by the *Madge* (left), the family steam launch. The propeller from the *Madge* is now at the Curtiss Museum in Hammondsport.

Isabel Drake also played the banjo. Martha looks interested, but Madge seems more taken with the camera.

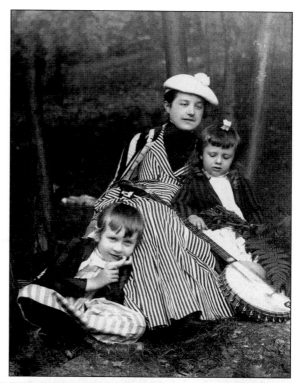

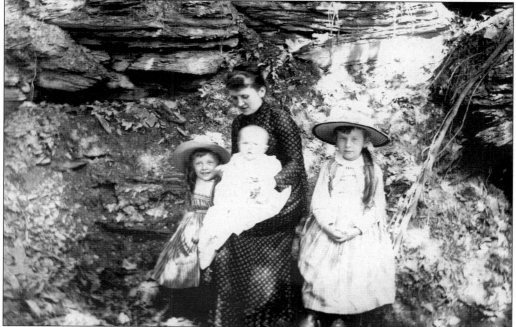

Isabel Drake got out in front of the camera for this 1888 portrait with Martha, Dort, and Madge. She posed both portraits on this page and, hiding the triggering device, probably also took the picture.

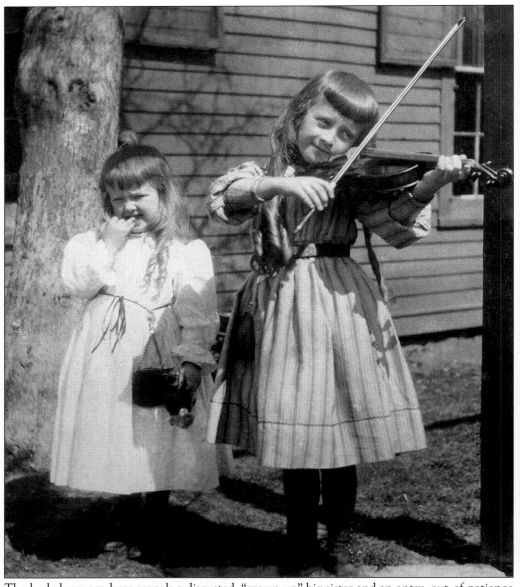

The body language here reveals a disgusted, "grown-up" big sister and an antsy, out-of-patience little sister. Some things never change.

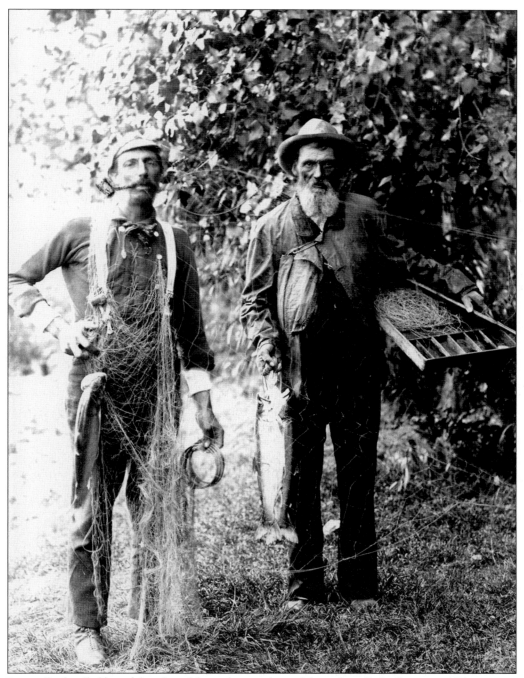

James Drake (left) and his friend have been taking fish with a Seth Green rig. This is not exactly how Green intended it to be used. The trout fishing is still excellent in Keuka, although nets (as seen here) at one time almost wiped out the trout.

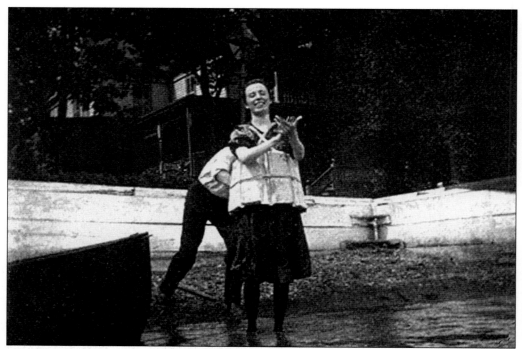

Very few people could swim in those days, and bulky absorbent swimming costumes did not help matters any.

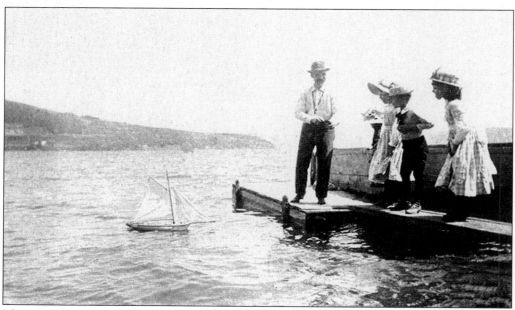

This is only a toy boat, but you can feel the excitement in the children's coiled poses.

This sort of action shot, very unusual for the day, demonstrates Isabel Drake's skill and originality. With the equipment and film available to her at that time, she was ahead of her day.

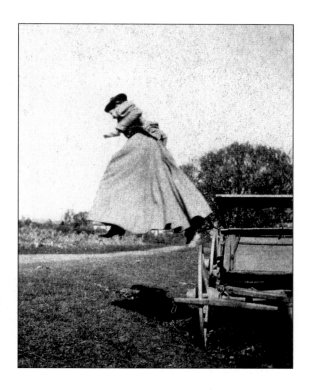

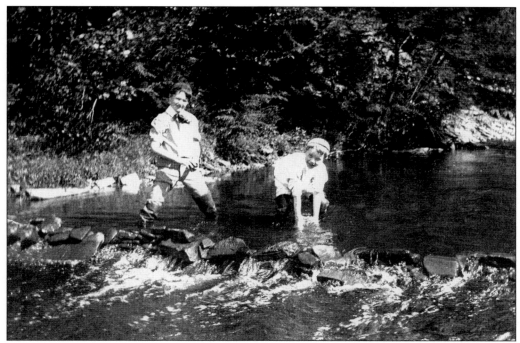

Sid and Glen Cole clearly enjoyed exploring. What boys can resist playing in a stream?

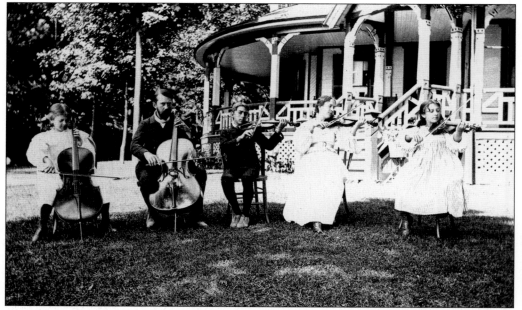

Being at the lake did not mean sacrificing artistic stimulation. Little ensembles, such as this one in front of Madge's Cottage *c.* 1895, were a steady feature of life at Drake's Point. From left to right are Dort Drake, Prof. John C. Bostlemann, John Bostlemann, and Madge and Martha Drake.

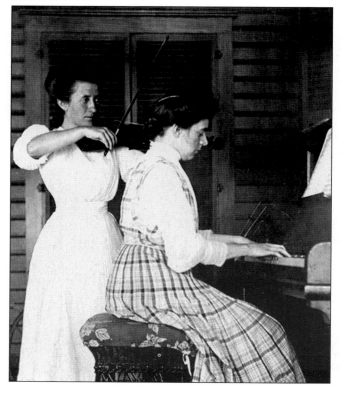

A grown Martha plays her Amati violin, accompanied by Maisie Cooper.

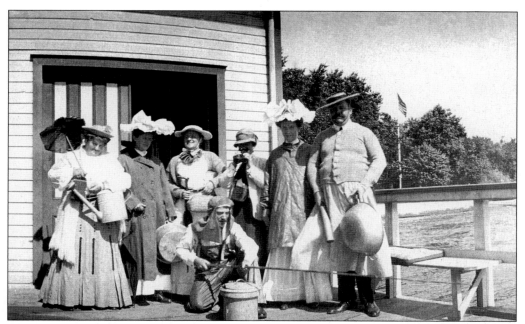

The home-grown theatricals carried on all summer. Did they use scripts they purchased, or were their own as elaborate as their costumes? This photograph was taken on the boathouse dock.

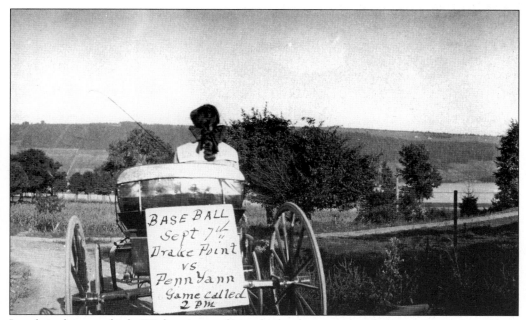

Local rivalries ran high. With a sign on her vehicle, she appears to have anticipated city buses or taxis. (Note the misspelled *Penn Yan*.)

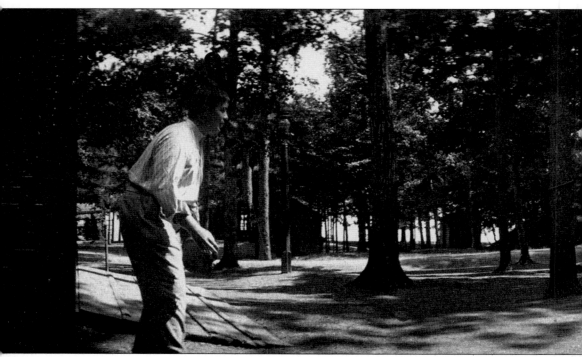

Baseball among the trees was part of the flavor of life at the lake. In center field is an icehouse,

The family also took in organized games, such as this match in Penn Yan. They are heading for

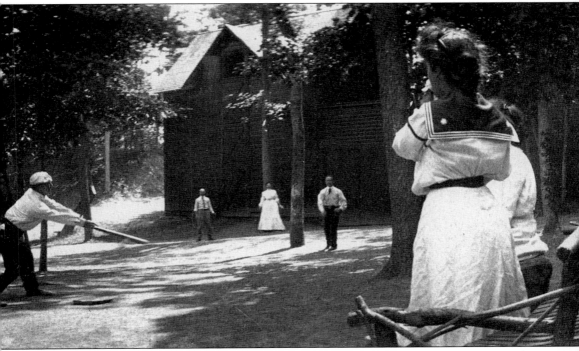

which fortunately has no windows.

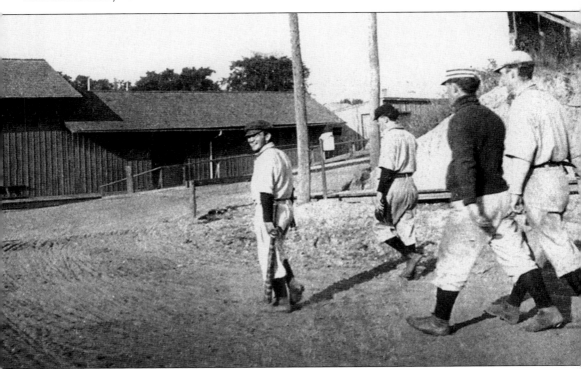

the docks, so they are probably going to take a steamboat back to Drake's Point.

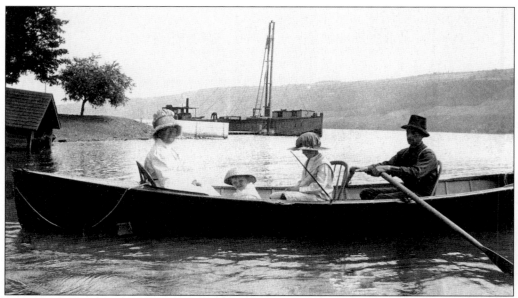

This double-ender shows the typical Keuka Lake pattern of outboard oarlocks. The steamer *Springstead* is working in the background.

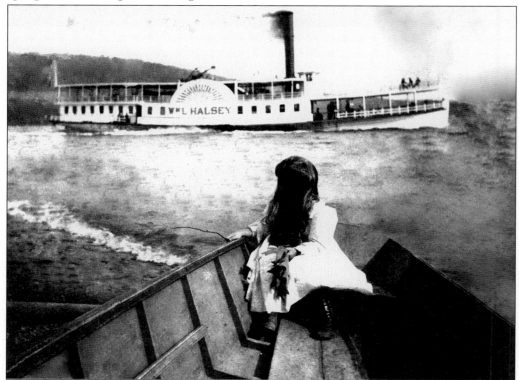

The *Halsey* was one of numerous passenger steamers cruising Keuka Lake on regular routes and schedules. Notice the sidewheel and walking beam. Isabel Drake has done a wonderful job catching the wistful romance of travel.

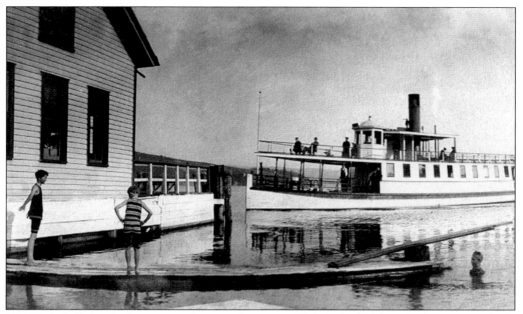

The Drake's Point dock was a regular steamboat stop. This is the *Cricket*, the last steamer built on Keuka but not the last to cease operations.

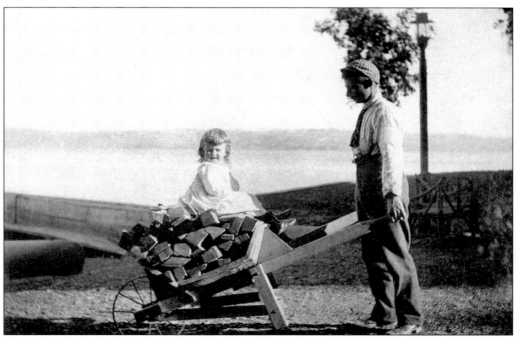

Wood was needed for cooking, of course. Notice how formally "Uncle Chester" is dressed.

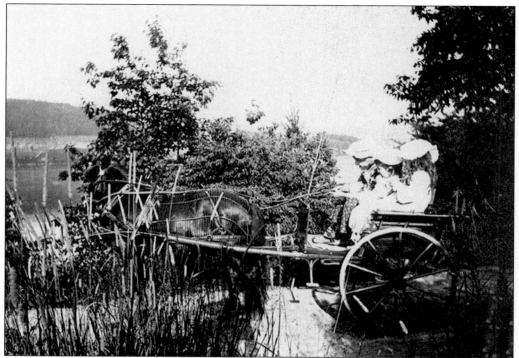

The Drake girls learned independence from a very early age. They rode all over their part of the lake in their pony cart.

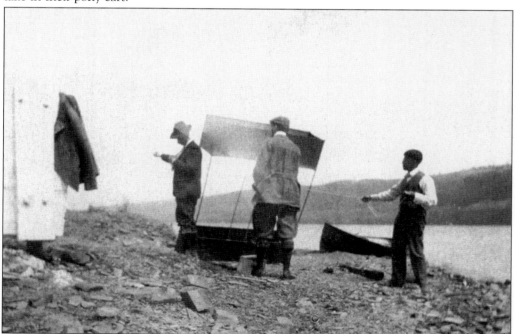

This box kite foreshadows very similar hang gliders and other early aircraft that will soon become prominent features on Keuka Lake. The photograph is dated August 29, 1897.

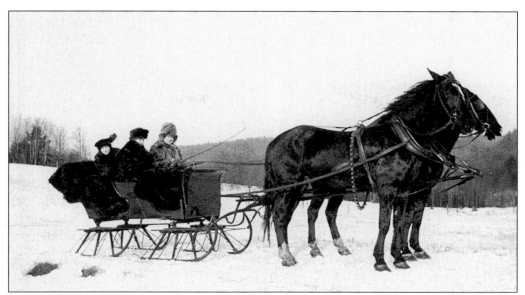

The Drakes also made winter trips to the lake. If the lake was frozen (and it usually was), there were sleigh rides, ice-skating, and iceboating.

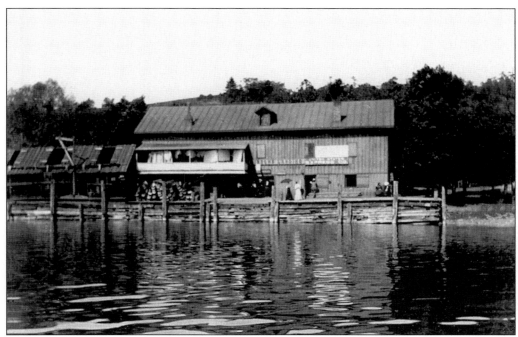

Gibson's Landing was a steamboat stop and post office on the west side of Keuka just a little south of Drake's Point. The large building shown here was later a skating rink and is still standing.

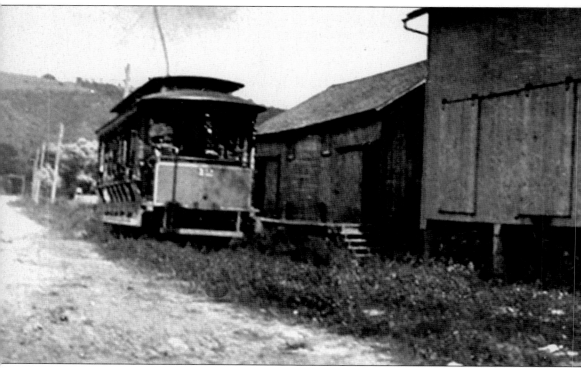

At Branchport, passengers could catch the Penn Yan, Keuka Park, and Branchport electric railway for Penn Yan. The Drakes would have traveled this way from their boat or a steamboat

The Wagener Mansion, which still stands prominently on Keuka's Bluff, was a popular Drake destination. Although it could be seen from Drake's Point, about a mile away, they had to go

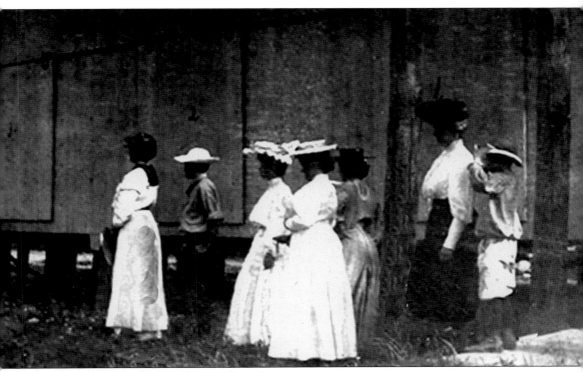

rather than the longer trip up the east branch.

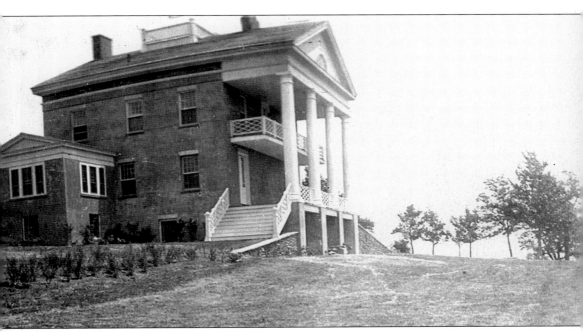

by boat or travel over 20 miles by road.

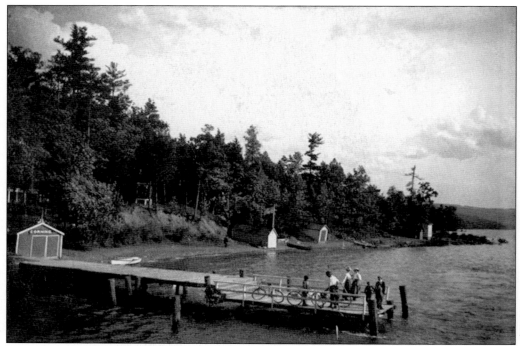

One point on the lake gathered so many summer people from Corning that it still bears the name Corning Landing.

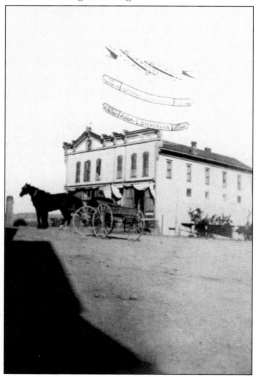

Democrats in Pulteney were backing Grover Cleveland and Adlai Stevenson (grandfather of the 1950s presidential candidate).

The striped outfits appeared in many of Isabel Drake's photographs that summer. Those are rather large springs on the hobby horse. It probably gave a vigorous ride.

This little girl is saying, "Wanna play?" with her whole face. Like most kids, if you get close to catch the ball, she will throw it past you.

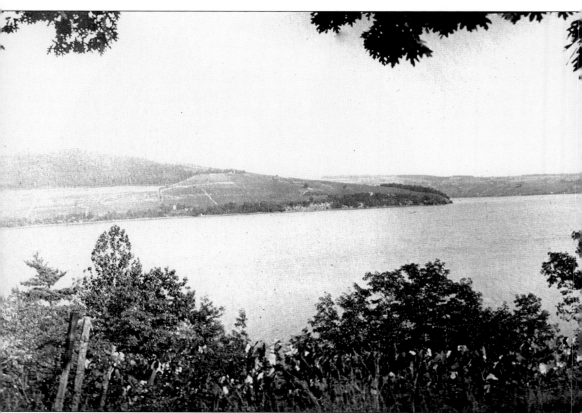

The vineyards above Drake's Point provide a great view in almost any direction. The views

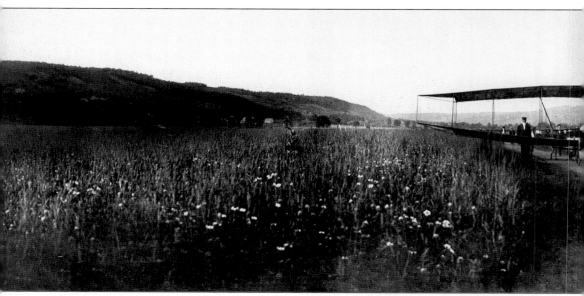

On July 4, 1908, Glenn Curtiss captured the *Scientific American* trophy by making America's first exhibition flight, outside Hammondsport at Pleasant Valley Wine Company. Isabel Drake

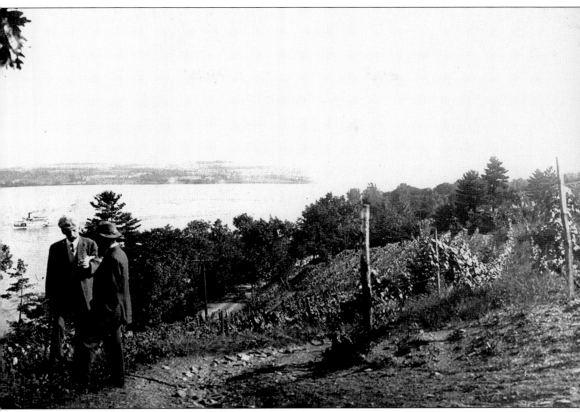

there were especially well represented by photographs taken with her panoramic camera.

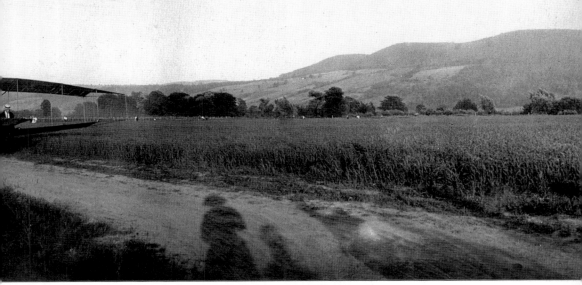

(notice her shadow) caught his second flight on the following day.

113

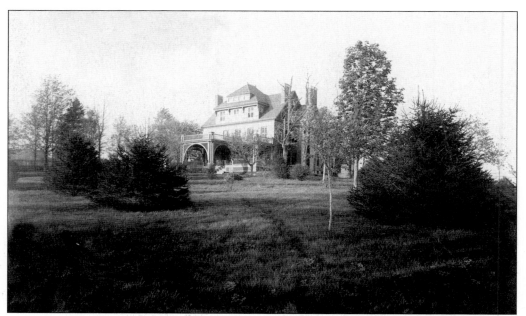

They also traveled farther afield. Isabel Drake's father, C.C.B. Walker, was a retired congressman. The Walker grandparents made their summer home at "the Farm" in Palmyra.

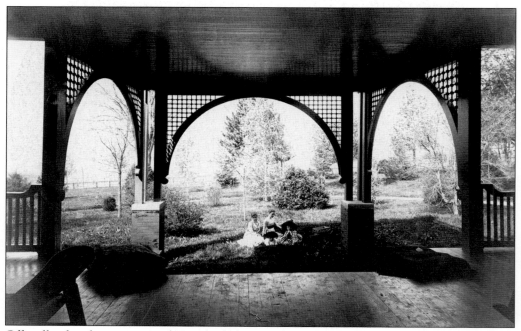

Officially, the place was named Viewforth, but no one in the family ever called it that. This was the carriage porch.

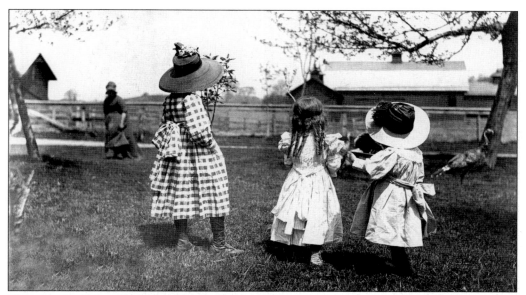

The girls are giving the turkey a wide berth. Although they visited the farm often, they were still city girls and not completely comfortable with some of the animals.

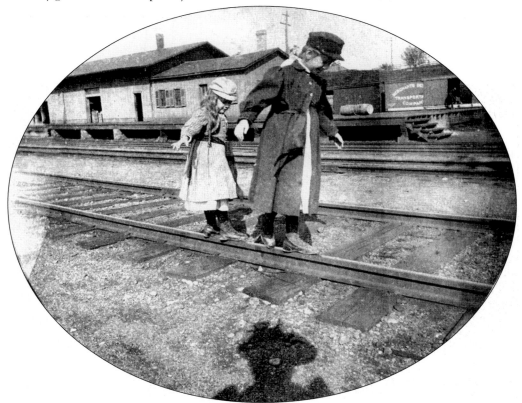

Getting from Corning to Palmyra meant making a change at Dresden, but this did not justify playing on the tracks. The shadow of Isabel Drake indicates that she was close-by.

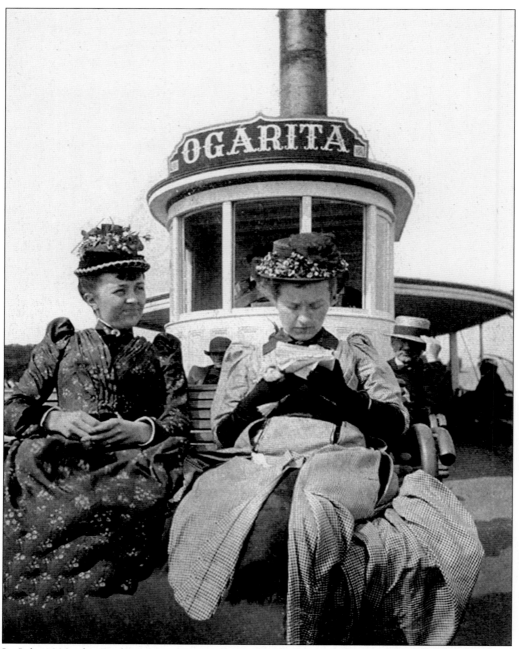

In July 1890, the Drakes cruised Canandaigua Lake. They may have gone to visit friends, or perhaps they just wanted to cruise on a lake with a different view.

The *Madge*, which took an hour to get up steam, was supplemented at some point by the naphtha launch *Ogontz*.

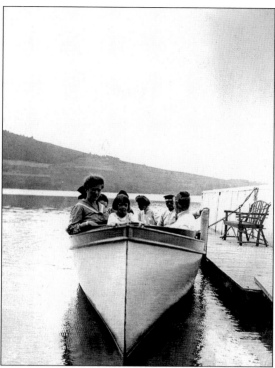

In August, the Drakes tried the Thousand Islands. As usual, Mrs. Green was handling the children.

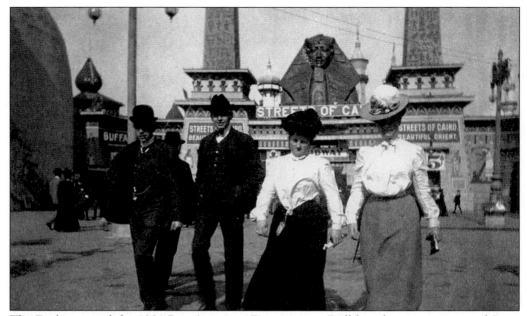

The Drakes visited the 1901 Pan-American Exposition in Buffalo, a hot attraction until Leon Czolgosz shot Pres. William McKinley dead in the Hall of Music.

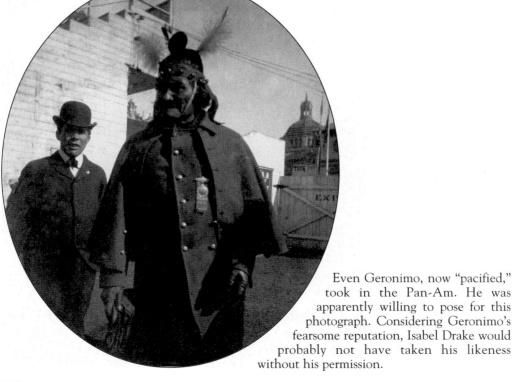

Even Geronimo, now "pacified," took in the Pan-Am. He was apparently willing to pose for this photograph. Considering Geronimo's fearsome reputation, Isabel Drake would probably not have taken his likeness without his permission.

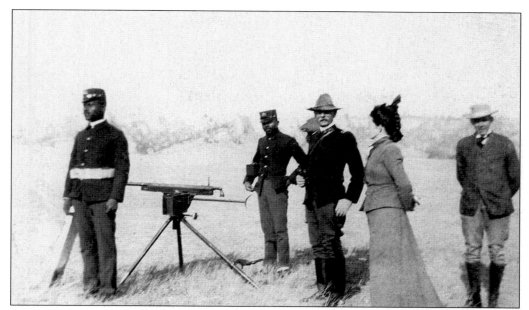

At Fort Robinson, Isabel Drake inspected troops that were adopting new weaponry despite their out-of-date blue uniforms. Isabel Drake, whose father had been a congressman, probably had the political pull to visit these maneuvers.

In New York City, the family saw the Dewey Arch, commemorating the victory of Manila Bay in the Spanish-American War. Patriotism was running very high at that time. The country had flexed its muscles and won.

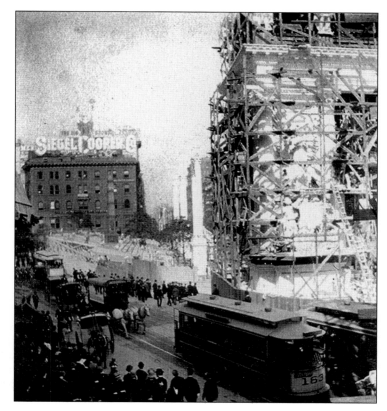

All three of the girls went to Ogontz Academy (now Penn State Abington) near Philadelphia. It looks like a stereotypical finishing school for girls from the upper economic strata.

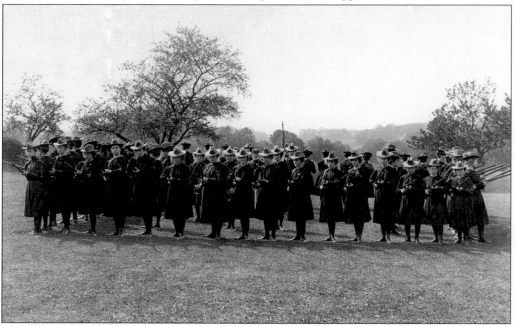

Ogontz was the only girls' school in America featuring military drill. They might successfully have defended their hollow square in the Sudan (assuming they had bayonets) but would have been sitting ducks for any fighting force with modern weapons.

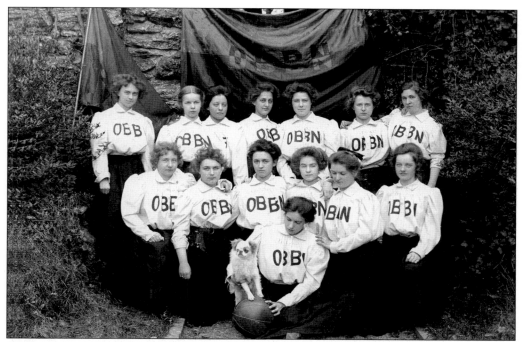

Sports were a vital part of life at Ogontz, although this gloomy group must have had a bad season.

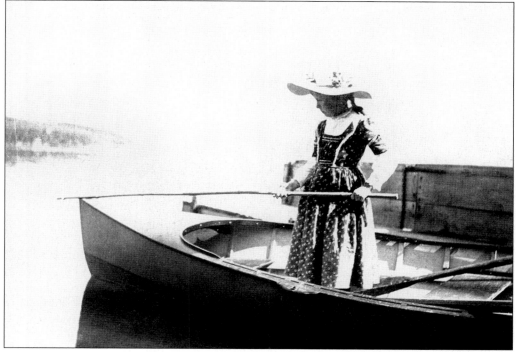

Fishing was another sport in which the girls participated, but from the well-dressed look, no fisherman would take her seriously.

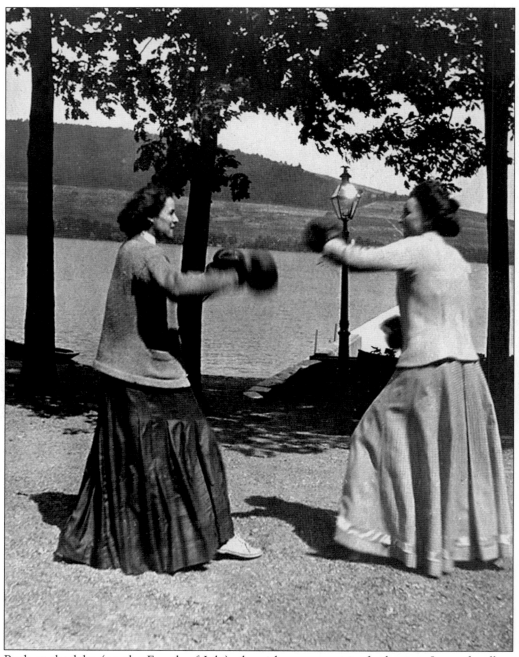

Back at the lake (on the Fourth of July), the girls even went in for boxing. It was hardly a genteel pastime for women at the time, but the Drake girls did not seem to worry about such things.

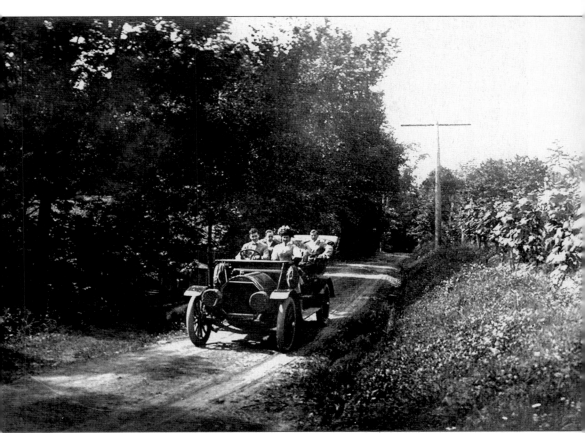

The Drakes often went touring in their automobile to various destinations near home. Here, they are seen driving along one of the Finger Lakes (judging from the grapes growing along the road). There were so few miles of paved roads at that time that travel was slow, dusty, and tiring. Those automobiles did not ride like our cars today.

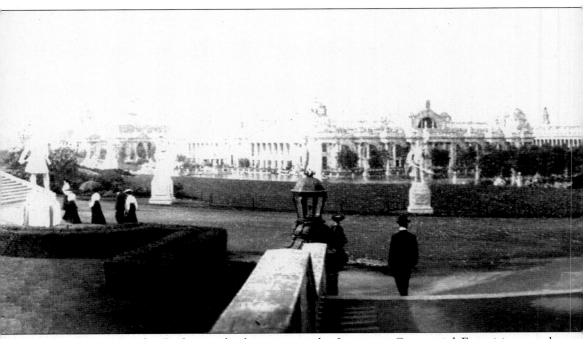

In 1903–1904, the Drakes made their way to the Louisiana Centennial Exposition, or the

One goal on their westward trips was inspecting James Drake's gold mines. There is no

124

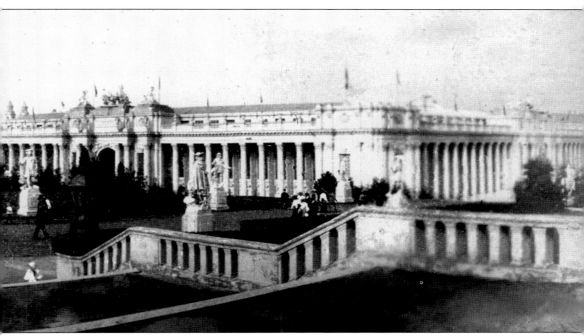

St. Louis World's Fair.

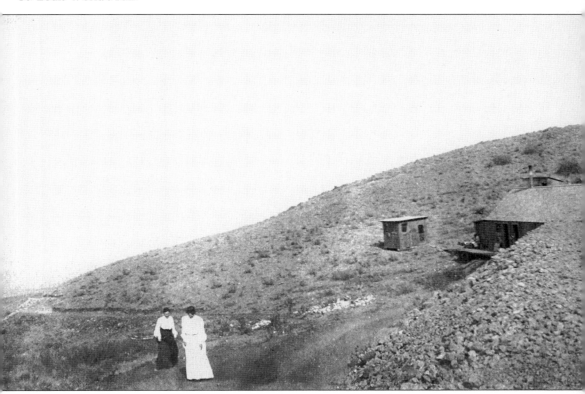

indication if the gold was a serious investment or an excuse to visit the West.

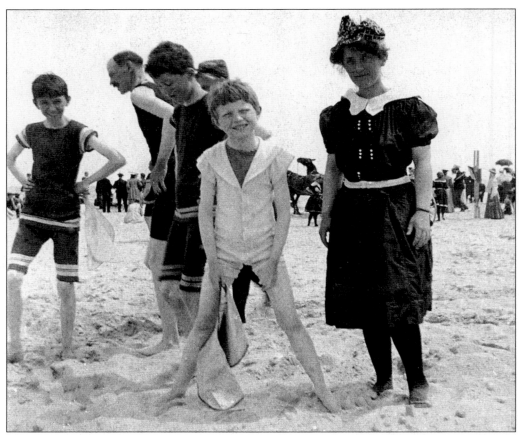

Glen Cole and Martha Drake enjoy Block Island in August 1904. James Drake is second from the left.

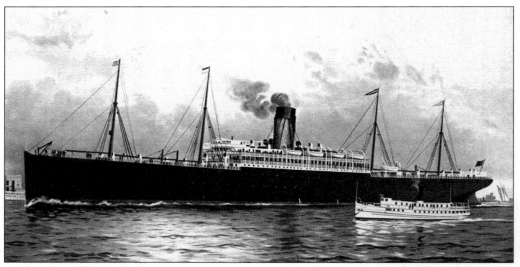

On May 4, 1907, Martha Drake sailed on the *Minnetonka* for a European tour. She was probably excited to learn that the actress Ellen Terry was also on board.

Martha Drake going off to Europe on her own was evidence (if anyone needed it) that the girls were growing up. The girls' mother was no doubt proud of them.

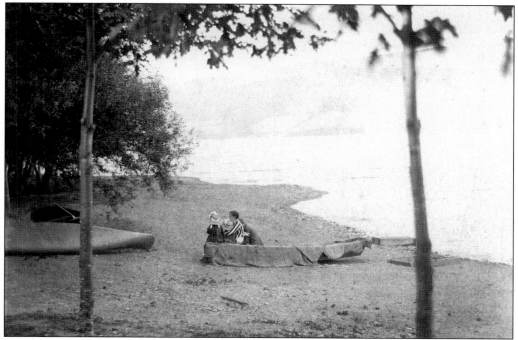

Isabel Drake undoubtedly had fond memories of her children's early days.

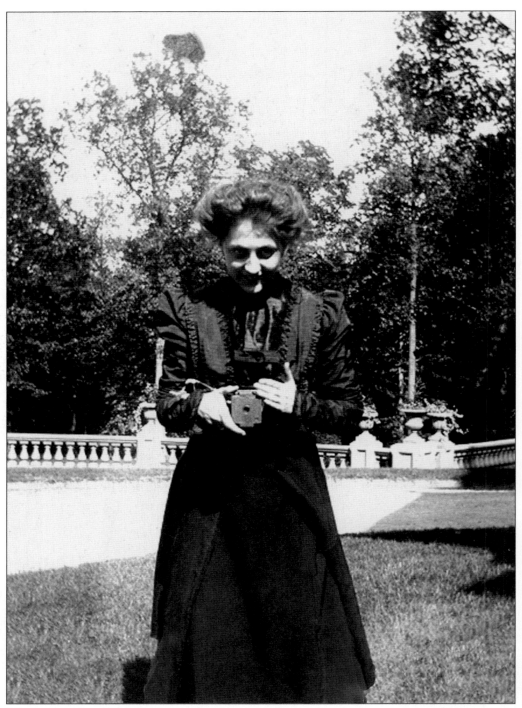

Like any mother, Isabel Drake needs one more picture.